Jo̶̶̶̶̶̶̶̶̶̶̶̶ Illustrator and Narrator

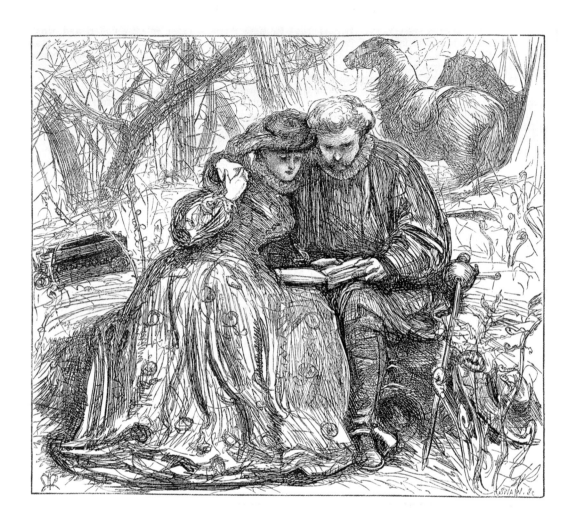

Wood-engraved illustration, *Sister
Anna's Probation*, 1862 (no.37, p.35)

John Everett Millais

Illustrator and Narrator

PAUL GOLDMAN

with an essay by TESSA SIDEY

Includes a catalogue of John Everett Millais
Drawings and Printed Illustrations at
Birmingham Museums and Art Gallery

LUND HUMPHRIES
in association with Birmingham Museums and Art Gallery

For Corinna *Paul Goldman*

For Doreen Lurring *Tessa Sidey*

First published in 2004 by

Lund Humphries
Gower House
Croft Road
Aldershot
Hampshire GU11 3HR

and

Suite 420
101 Cherry Street
Burlington
Vermont, VT 05401–4405
USA
www.lundhumphries.com

Lund Humphries is part of Ashgate Publishing

in association with Birmingham Museums and Art Gallery

Supported by the
Resource/DCMS
Designation
Challenge Fund

British Library Cataloguing-in-Publication Data
A catalogue record for this book is available from the British Library

Library of Congress Control Number 2004106093

ISBN 0 85331 911 1

Designed by Sally Jeffery
Printed in Slovenia under the supervision of Compass Press Ltd

Published to coincide with the exhibition
John Everett Millais: Illustrator and Narrator
Birmingham Museum and Art Gallery 16 October 2004 – 16 January 2005
Leighton House Museum, London 18 February – 29 April 2005

Contents

Introduction and Acknowledgements

There are three main aims in presenting *John Everett Millais: Illustrator and Narrator* to the public. The first is to reveal, through the drawings, watercolours and wood-engravings, the artist as an illustrator of books and periodicals of genuine stature and distinction. While many of his paintings are well known and frequently reproduced, his thoughtful and sensitive designs for publication remain unjustifiably neglected. The second is to draw attention to the major collection of works by the artist housed in the Birmingham Museums and Art Gallery. A third intention is to show the artist himself as far more than an illustrator – indeed as a storyteller in his own right.

My thanks go first to Tessa Sidey, Curator of Prints and Drawings in Birmingham, who has been a constant support, guide and mentor. She in turn would especially like to acknowledge the help and expertise of David Elliott and Malcolm Warner; Daniel Robbins for providing a particularly appropriate London venue for the exhibition at Leighton House; and Anne and Martin Kenrick, Pat Welch and The John Feeney Charitable Trust, and Michael Fea for their advice and financial contributions towards this publication.

I wish also to express my gratitude to the lenders – to institutional colleagues, Stephen Calloway at the Victoria and Albert Museum; Colin Harrison and Christopher Brown at the Ashmolean Museum, Oxford; Antony Griffiths and Janice Reading at the British Museum; Birmingham Reference Library; and two individuals, Robin de Beaumont and Sir Geoffroy Millais. Both the latter warrant my heartfelt thanks for having so regularly provided encouragement in my endeavours in the field over many years.

Finally I acknowledge the help of Brian Allen and Frank Salmon at the Paul Mellon Centre for Studies in British Art for providing me with a research support grant, Jonathan Jones and Alison Green at Lund Humphries for undertaking and seeing this publication through to realisation, and Sally Jeffery for her design skills.

Paul Goldman

John Everett Millais: Illustrator and Narrator

PAUL GOLDMAN

The received opinion on John Everett Millais (1829–96) today is essentially a mixed one. He is rightly recognised as a pioneering founder of the Pre-Raphaelite Brotherhood together with Dante Gabriel Rossetti and William Holman-Hunt in 1848 and also as a significant and advanced painter, chiefly on account of his earlier years. He remains of interest too for social commentators and biographers, not least on account of his falling in love with and indeed marrying Euphemia (Effie) Gray, the wife of John Ruskin. This highly romantic story continues to exert a fascination for the curious and even the prurient. However, in complete contrast, his artistic reputation has dipped more than a little, as is revealed by a recent valuation 'From the time of his marriage Millais abandoned Pre-Raphaelite technique for a broader, more painterly, style and Pre-Raphaelite seriousness for vapid sentimentality, epitomised by *The Boyhood of Raleigh* [1870; London, Tate], which pleased his Victorian audience and ensured worldly success.'[1] Such an assessment is, however, one-sided at best, and successive exhibitions, two devoted to him as a draughtsman and one examining him as a painter, have attempted to retrieve him from the relative critical void into which he has fallen, and to tip the balance once again rather more in his favour.[2] Both exhibitions of his drawings went some way to reveal his brilliance of hand, while the Southampton survey drew long overdue attention to several particularly neglected areas, most notably perhaps the large and luminous late oil landscapes.

The present exhibition and catalogue are an attempt to challenge current thinking about Millais as a facile and brilliant prodigy, yet at the same time a somewhat superficial and even a meretricious artist – a shooting star who plummeted to earth, his initial promise sadly unfulfilled. Instead, by concentrating on his drawings related to illustration, it is intended to reveal him as a serious, intelligent and, frequently, even a profound artist.

Millais's published illustrations present immense difficulty to scholars, critics and admirers alike. There are numerous reasons for this. First is the fact that they appeared over a number of years in a host of books and periodicals, some of which are today extremely rare and frequently absent even from national libraries and museums. In other words, their scattered nature makes it an awkward task to see them easily or completely. Then it must be admitted that when published the illustrations often saw the light of day carelessly printed on cheap paper stock, which means that to the casual observer, they regularly fail to make the impact that they

should. Thirdly it should be mentioned that in many collections the printed images have been cut out (especially from periodicals) and mounted apart from their original texts, hence rendering them all but incomprehensible, except as tiny examples of the artist's output.[3] There also remains the very real problem of the perception of illustration as an art form in its own right. There clearly exists today an unspoken yet palpable 'pecking order' in which any artist's achievements seem to be judged. Painting and sculpture remain at the pinnacle, followed by drawing, then single-sheet printmaking and far behind, if it is considered at all, illustration.

There are several entirely understandable reasons for this state of affairs, but perhaps the most significant one is the fact that illustration is, by its nature, inextricably related to text, so there is, at the back of the mind, some niggling feeling that an artist's illustrations are perhaps not quite so 'original' as other aspects of the oeuvre. Finally, there is extant the perception that since Millais and his contemporaries handed their drawings for illustration to firms of wood-engravers such as the Dalziel Brothers and Joseph Swain to be engraved, again their achievements in this area are, in some curious way, diminished in stature. The contemporary wood-engraver does indeed both design and engrave his or her blocks, hence rendering them undoubtedly autographic (as if this feature alone is somehow proof of creative worth), no matter how enfeebled and vacuous many of their productions may be when considered from a purely artistic viewpoint. While no critic would dream of demeaning the woodcuts of Albrecht Dürer or Hans Holbein the Younger on account of their having been cut by members of guilds, it seems inconsistent, to say the least, to treat the illustrations of the Victorian artists so frequently as of little note merely because they were reproduced by similar means.

In the case of Millais it is undoubtedly fair to assert that his approach to the art of illustration is one which betrays several remarkable qualities including originality in design and conception and, in almost every case, a deep sincerity. In addition, his industry, his prolific achievement, and perhaps most notably, his variety of utterance all point to an illustrator and artist of a higher than average ability and intelligence.

It is worth mentioning too that as a productive worker Millais's career in the field lasted from 1852 to 1883.[4] Unlike all his Pre-Raphaelite contemporaries, he continued to be seriously interested in illustration as an occupation throughout his career. Indeed he made well over 300 designs for illustration, which is a figure far in advance of, for example, Rossetti or Ford Madox Brown. The former produced just ten and the latter fewer than 20 images in total, and both artists abandoned illustration early in their careers. The variety, complexity and sophistication both in the artist's style and in his interpretations of his texts lie at the heart of this exhibition and the accompanying publication.

When taken as a whole it can be seen that the illustrations may be divided into several different categories. First there is the poetry, almost all of it reprinted and

aimed at adults, which appeared almost exclusively in book form. Most notable of this kind in the present show are the edition of Alfred, Lord Tennyson's *Poems*, known as *The Moxon Tennyson* (nos 5–12) 1857, for which the artist made 18 designs; Robert Aris Willmott's *The Poets of the Nineteenth Century* (no.17) 1857; and *Lays of the Holy Land* (no.18) 1858. It was customary to publish poetry initially unillustrated before estimating whether the market could bear an illustrated edition and it was certainly never guaranteed that these luxurious gift books would turn a good profit. Indeed, it is not fanciful to surmise that the death of the publisher of the Tennyson volume, Edward Moxon, in 1858 at the age of 57, just a year after publication, was hastened by anxiety over the costs involved and paucity of sales.

Novels for adults form another type of literature to which Millais made a major contribution in terms of illustration. His first published design is for Wilkie Collins's *Mr Wray's Cash-Box* (no.4) 1852 and the Birmingham collection has yielded a preparatory drawing for this image, hitherto unrecognised (no.3). Arguably the artist's greatest achievement in the illustration of novels is for the work of Anthony Trollope. There are examples in the exhibition, notably nos 27, 28 and 32 relating to *Framley Parsonage*, which was published initially in the *Cornhill Magazine* during 1860–61. Millais illustrated several other works by the author, most notably perhaps *Orley Farm* (1862) and *The Small House at Allington* (no.42) 1862–4. The relationship between author and illustrator is a remarkable one which is well known and documented.[5]

Yet it is also true to say that some of the artist's best illustrations are for other writers, and in this exhibition, those drawn for Dinah Mulock's (Mrs Craik) *Mistress and Maid* (no.41), and Harriet Martineau's *Sister Anna's Probation* (nos 36–7) and the same author's *The Anglers of the Dove* (nos 38–40) have an equal claim on the viewer's attention. While most of the adult poetry which Millais illustrated was reprinted, this is not generally the case of his work for novels and stories. These were invariably published either in parts or serially in magazines and they were examples of contemporary literature which Millais had to deal with relatively quickly, meeting strict deadlines set by publishers, printers, engravers and magazine proprietors. One significant exception to this rule is William Makepeace Thackeray's *The Memoirs of Barry Lyndon* (nos 45–8) 1879, a reprint to be sure, but one to which Millais, late in his career as an illustrator, brought an unique feeling for figures in period costume. The preparatory drawings reveal a sensitivity to female pose and dress which warrants comparison even with an artist of the stature of Jean Antoine Watteau, who was an undoubted master of the genre.

In the area of religious literature Millais produced a single outstanding masterpiece. This was *The Parables of Our Lord*, a group of 20 designs published in book form in 1864.[6] These remarkable images, in which Millais almost retells the stories themselves by placing the texts in an approachable and recognisable Scottish

landscape setting, still retain the power to move and inspire (nos 13, 15–16). He clearly found the entire project a daunting one and at first intended to produce 30 designs in all.

He began work on the drawings in 1857, but by the time of the publication of the book seven years later just 20 images had been completed. Millais wrote of his difficulties and trepidation to his engravers, the Dalziel Brothers. In this undated letter we read:

> It is almost unnecessary for me to say that I cannot produce these quickly even if supposing I give *all my* time to them. They are separate pictures, and so I exert myself to the utmost to make them as complete as possible. I can do ordinary illustrations as quickly as most men, but these designs can scarcely be regarded in the same light – each Parable I illustrate perhaps a dozen times before I fix, and the 'Hidden Treasures' I have altered on the wood at least six times. The manipulation of the drawings takes much less time than the arrangement, although you cannot but see how carefully they are executed.[7]

The Dalziel Brothers wrote of their own reaction to Millais and the *Parables:*

> Millais produced several of the drawings very promptly, but, as time went on and he became more popular – the demand for his pictures daily increasing – longer intervals gradually took place between the delivery of the drawings, and it was not until the end of 1864 that the last was sent in. Even then he had only made twenty drawings out of thirty, which he first undertook to do. At the same time he requested us to release him from the remainder of the agreement, and to this we had no choice but to comply, though we did so very reluctantly, feeling that the world of art would be so much the poorer.[8]

Millais reveals in his letter something of the internal struggle he encountered to work at an elevated level of thought and draughtsmanship, while the Dalziels, hard-headed businessmen though they were, forcefully convey their unswerving belief in the significance of the undertaking.

While it is not possible in a relatively small exhibition to do justice to all aspects of Millais's achievements as an illustrator, especially perhaps his books for children, there is sufficient here to suggest something of his variety, and the way in which he tailored his style to his texts is worthy of examination. In *The Moxon Tennyson* we discern several contrasting moods. The first might be called the consciously mediaeval and this is particularly resonant in *St Agnes' Eve* (nos 5, 6, 52) and in *The Lord of Burleigh* (nos 7, 51). The method goes far beyond the mere use and mastery of antique costume and is apparent in pose and gesture as well. For example, in *St Agnes' Eve*, the standing central figure who dominates the composition is entirely Pre-Raphaelite in design, but the atmosphere created, with the enraptured gaze from the window and the breath made visible in the chilly air, is suggestive of a distant and imaginary past – a view that was utterly unreal but one which appealed to so many of these artists at this moment in their development. Such a design might be

FAR RIGHT *The Lord of Burleigh* as illustrated in Tennyson's *Poems*, 1857 (no.51, p.40)

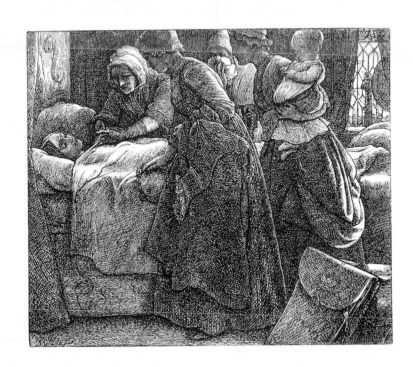

THE LORD OF BURLEIGH.

In her ear he whispers gaily,
　"If my heart by signs can tell,
Maiden, I have watch'd thee daily,
　And I think thou lov'st me well."
She replies, in accents fainter,
　"There is none I love like thee."
He is but a landscape-painter,
　And a village maiden she.

Z Z

compared with *Edward Gray* (no.8) where Millais reveals an understanding not just of contemporary dress but also of the powerful emotions bubbling just beneath the surface. The use of the two figures both turning away in anguish from the viewer renders the scene full of a deeply felt disquiet, and its depiction seems entirely up to date. This approach might then be termed his modern style.

In the same book we find also an interest in architecture and in physical objects – the extraordinary moonlit monument which opens *The Sisters*, for example, is entirely conjured from the artist's imagination and does not appear as the artist shows it, in the text of the poem. In *St Agnes' Eve* (nos 5, 6, 52) in contrast, the turret staircase is rendered with great attention to the roughness of the stone although, once again, as depicted by Millais, it does not occur, strictly speaking, in the Tennyson.

Looking at these varying approaches we see also that the moment which Millais chooses to illustrate is rarely the conventional nor invariably even the most obviously dramatic one. Sometimes he reacts to the mood suggested by the text, as just noted; at other times, as in *A Dream of Fair Women – Cleopatra* (no.12), the words are reflected with a fastidious attention to detail. Far from being a somewhat bloodless technician then, Millais betrays, on more than one occasion, a passion which can be both powerful and disconcerting. One of his most remarkable designs in this manner is surely *Love* (no.17) while similarly in *A Lost Love* (no.23) the rapt intensity of the design outshines the pitiable doggerel in every respect, but also ironically endows it with a distinction it scarcely warrants.

The periodicals form a significant part of any examination of Millais as an illustrator. As already mentioned they reveal him working quickly, almost invariably for new literature and meeting deadlines. Two chief consequences can be made out. First is the mixture of texts, with the artist forced to deal not just with prose and poetry but also with good, mediocre and, on occasion, downright poor material. As a partial result of this *mélange*, as well as the pressure to produce work at speed, there are clearly perceptible changes in composition and handling.

The designs for *Once a Week* encompass those for Tennyson's fine poem *The Grandmother's Apology* (nos 19, 20, 54), another for Christina Rossetti's *Maude Clare* (no.24) as well as drawings for a poem translated from the Breton, *The Plague of Elliant* (no.22) and *Violet* (no.29), now identified as a depiction of the artist's wife, Effie. *Once a Week* is a significant journal because it gave an opportunity for several artists, some at the beginning of their careers, to show their skill in many aspects.

George du Maurier reveals something of the competitive and febrile atmosphere engendered by contributing to this weekly miscellany, which emanated from Bradbury and Evans, the publishers of *Punch*. Writing to his mother in October 1860 du Maurier remarks:

There was no sketch of mine in this week's Once a Week, nor will there be in next, as they are crammed full of drawings of Millais. The brutes have not taken the trouble to

pay me, though, so you will have to send me a fiver; Once a Week and Punch owe me 16 guineas for last month's work, and have not sent me the cheque, the consequence is I am deuced hard up, and feeding on borrowed money. I must now tell you, old lady, that I have decided not coming over this month to Dusseldorf for these reasons – Keene's going out of town and I wish to exploiter [*sic*] his absence as I have done that of Leech and Millais; Such is everybody's advice.[9]

Working swiftly in order to satisfy the needs of a weekly publication, Millais frequently resorts to a kind of shorthand in drawing. A clear example is in *Maude Clare* (no.24) where the hatching on faces and clothing is reduced to a series of vertical, horizontal and angled dashes. It is perhaps even clearer in the published engraving than in the drawing and, while it suggests haste and abbreviation, it also renders the subject full of movement and vivacity.

Millais's work for the periodicals is of such significance that any understanding of his work as an illustrator is incomplete without reference to them. While he made designs for several, three are of outstanding interest – the *Cornhill Magazine*, *Good Words* and *Once a Week*. The first of these organs was the weightiest intellectually, and it began in January 1860 with Thackeray at the editorial helm. From the outset it published literature by most of the leading poets and writers of the day, notably Trollope, Thackeray himself, George Eliot, Elizabeth Gaskell, Elizabeth Barrett Browning and John Ruskin among a host of others.

Millais's distinguished contributions were made chiefly for the Trollope novels serialised here, such as *Framley Parsonage* and *The Small House at Allington*. *Good Words* was started in Edinburgh by Alexander Strahan but swiftly moved to London as a direct competitor of the *Cornhill*. It was seen by its proprietor as somewhat less avowedly highbrow and more of general interest, and it contained a wide mix of topical articles as well as literature of arguably lesser stature. Nevertheless, Millais produced for it a series of fine designs for Dinah Mulock's *Mistress and Maid* and the first 12 of *The Parables of Our Lord* appeared in the magazine during 1863. *Once a Week* was essentially a miscellany of articles, poems and stories emanating from the same stable as *Punch* and was, at the beginning, guided by an inspired editor, Samuel Lucas (1818–68). It has many claims to being the most remarkable illustrated periodical of the entire period, and Millais made some of his finest illustrations for it, most notably for the stories of Harriet Martineau (see nos 36–40). It is worth mentioning also that, at least for a time, it attracted a galaxy of artistic talent including, among others, Holman-Hunt, James Abbott McNeill Whistler, Frederick Sandys and Charles Keene to name but four.[10]

By all accounts Millais's success as an illustrator had a lot to do with a good working relationship with his engravers, especially the Dalziel Brothers. As already mentioned in connection with *The Parables of Our Lord*, he was in regular touch with them over his approach to the work and he clearly understood exactly what was

required by them in order to achieve a successful result. In this way he differed utterly from the other Pre-Raphaelites who generally found drawing for engraving irksome and time-consuming. Unsurprisingly they turned away from the process early on and only Millais of the group continued to design for illustration for most of his career.

The medium of wood-engraving became the preferred means of illustrating books and periodicals at this time because, being printed in relief, the blocks could be set up with the letterpress and printed at one and the same time. The speed and economic advantages which the technique permitted made it ideal for mass-market publication. The Dalziels and Joseph Swain both ran large engraving workshops in London, although their engravers usually worked at home for low wages and often overnight to meet tight deadlines. Many are thought to have been women, but few of their names are known, being subsumed instead into the name of the firm itself.

Drawings supplied by artists were transferred to the wood blocks either physically (by being placed on top and then cut through with the engraving tool) or by being photographed with the resulting image becoming the template through which the engraver worked. The actual wood-engraving process required good eyesight, great ability to control the engraving tool (a version of the burin or graver used in copper engraving) and a certain amount of physical strength. The handle is held against the palm and the blade is pushed before the hand, ensuring a clean incision into the hard wood. At this period boxwood, named after Box Hill in Surrey where the trees grew in some quantity, was always used. It is a very hard wood but today expensive and mostly imported from Turkey. The engravers responsible for reproducing Millais's designs were remarkably skilled, intelligent and sensitive artists themselves, and another entire study would be required to do full justice to their achievement.

Millais made a small number of etchings during his long career and since virtually all are related in one way or another to illustration I make no apology for including several here. Of special importance is *St Agnes of Intercession* (no.2) – made very early in his life when he was working at the zenith of intensity in true Pre-Raphaelite mould – one of just three extant impressions. It is shown together with a preparatory drawing (no.1).

A Penny for her Thoughts (no.50), made nearly 40 years later, makes one regret that he did not do more with the etching needle since he is clearly so entirely at home with the medium. Philip Hamerton saw Millais as a natural etcher, remarking 'His manner of sketching is an excellent manner for an etcher. It is delicate without over-minuteness, and it is rapid and free without neglecting anything essential.'[11] A related drawing (no.49) reveals again that Millais took consummate care over every aspect of preparation for printing and publishing.

It is also known that Millais was meticulous in the correction of proofs and in the manner of producing drawings for the engraver. His method was first to make rough preparatory drawings in pencil (such as no.1), then produce designs of particular

figures (for example no.8). From these beginnings he would move on to a finished design which was very close to what it would look like when engraved (such as no.29). Then the finished image was transferred to a boxwood block in reverse, possibly with the help of tracing paper. When Millais undertook the process himself these final sheets were almost invariably destroyed in the cutting. By 1863, however, technology had moved on and such drawings could be transferred photographically, so many more of them survived. This sometimes enabled the artists to be paid twice over, not only by the engraver or the publisher, but also by selling their completed designs to collectors and patrons.

The blocks themselves are of great interest. A small number have remained drawn but not engraved (nos 16, 33, 41) and those that were engraved were used almost exclusively for taking proofs. Such proof impressions were taken by the engravers and returned to the artist for correction and retouching (see no.44). Normally Millais made his painstaking corrections both in graphite and in Chinese white and, when satisfied, would return these marked proofs to the engraver for the alterations to be added to the blocks. Almost invariably, however, the impressions published in the periodicals, and regularly even those encountered in books, were not printed directly from the boxwood blocks, but instead from metal electrotype facsimiles. These were exact duplicates of the original blocks produced by a process of electrolysis which had been invented in 1839. Far finer facsimiles could be produced by this method than had been possible using the preceding system which was called stereotyping, in which duplicates were created using a mould. This ensured that should an electrotype be damaged or broken, it would be a relatively simple matter to create a replacement using the original wood block as a master.[12] This master block was carefully retained and, through the electrolysis method mentioned, a new electrotype could be 'grown' from which identical impressions of excellent quality could be taken. It is often said that it is possible to perceive when a wood-engraving has been printed from the original wood and when from a metal electrotype. I would argue that a properly printed impression from a metal matrix is frequently just as fine in terms of detail and quality as one taken from the wood. Both the electrotypes and the blocks were reprinted again and again in publications of all kinds. Millais's designs reappear with regularity, often accompanying texts for which they were never intended and in increasingly poor impressions. This practice ceased in the 1880s when photographic techniques (such as the line block and the half-tone) began to replace wood-engraving for illustrations in trade (as opposed to private press) books.

In 1893 the Dalziel Brothers' firm went into receivership, and their prized blocks became virtually worthless and were discarded in enormous numbers. As a result, comparatively few blocks from the 1860s survive today. The entire engraved output of the Dalziel Brothers, however, amounting to some 54,000 impressions and

showing every image produced between 1839 and 1893, is kept in the Department of Prints and Drawings at the British Museum.

The exhibition also includes some of the highly refined and delicate versions of illustrations which Millais executed in watercolour. Two notable examples, *A Lost Love* (no.23) and *A Wife* (no.26), reveal the artist at the height of his powers of draughtsmanship and as a master of colour. It seems that Millais regularly made such watercolours after the wood-engraved designs, presumably for presentation or for sale. They are among the loveliest and least self-conscious works that he ever undertook, although their dating is sometimes problematic. They are generally signed in monogram and are often highly finished.

Despite some failures, most notably perhaps the dull drawings for Trollope's *Phineas Finn: The Irish Member* in the *St Paul's Magazine* (1867–9), Millais is, on the whole, an illustrator who had much to say in response to his texts. His variety, his attention to detail, his mature comprehension and feeling for literature, not all of which was of the highest quality, together with a sensitivity and breadth of vision mark him out as an illustrator of real distinction. He took the art of illustration forward in so sophisticated a manner that it is fair to assert that he himself also tells the story – one that enlarges and enhances the written word. In this remarkable way he may be seen truly as both illustrator and narrator.

Notes

1 Hugh Brigstocke (ed), *The Oxford Companion to Western Art*, Oxford, Oxford University Press, 2001, p.479.

2 Malcolm Warner, *The Drawings of John Everett Millais*, London, Arts Council of Great Britain, 1979. Annette Wickham, *The Gifted Hand – Drawings by John Everett Millais from the Royal Academy's Collection*, London, Royal Academy of Arts, 2003. Claire Donovan and Joanne Bushnell, *John Everett Millais 1829–1896 – A Centenary Exhibition*, Southampton, Southampton Institute, 1996.

3 Several public institutions contain collections thus ordered. Two of the most important are in the Ashmolean Museum, Oxford (Forrest Reid Collection) and the University College of Wales Print Collection, Aberystwyth.

4 His first illustration was an etched frontispiece for Wilkie Collins's *Mr Wray's Cash-Box* (1852). See catalogue nos 3 and 4. His last was a wood-engraved frontispiece for Anthony Trollope's *Kept in the Dark* (1882). However, also of note is the enlarged reprint of Henry Leslie's *Little Songs for Me to Sing* (1865) entitled *Leslie's Songs for Little Folks* (1883) which contains a new frontispiece made in 1854 but not published until this later date.

5 See Michael Mason, 'The way we look now: Millais' illustrations to Trollope' in *Art History*, vol.1, no.3, September 1978,

pp 309–40; N. John Hall *Trollope and His Illustrators*, London, Macmillan, 1980; and Jane Munro *Tennyson and Trollope – Book Illustrations by John Everett Millais*, Cambridge, Fitzwilliam Museum, 1996.

6 The first 12 illustrations appeared monthly in *Good Words* in 1863.

7 British Library Department of Manuscripts, Add. 38974, ff 194, 195.

8 *The Brothers Dalziel – A Record of Fifty Years' Work*, London, Methuen, 1901, pp 97–8.

9 Daphne du Maurier (ed), *The Young George du Maurier – A Selection of his Letters 1860–67*, London, Peter Davies, 1951, pp 18–19.

10 For a more detailed discussion of the illustrated magazines of the period see the present author's *Victorian Illustrated Books 1850–1870 – The Heyday of Wood-Engraving*, London, British Museum Press, 1994.

11 P. G. Hamerton, *Etching and Etchers*, London, Macmillan, 1876 edition, pp 339–40.

12 For Millais's methods see also Malcolm Warner, *The Drawings of John Everett Millais*, London, Arts Council of Great Britain, 1979, p.14.

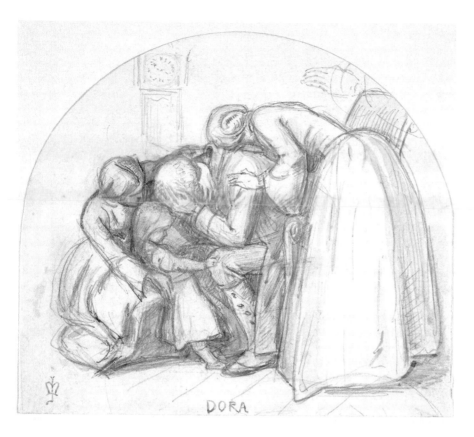

DORA

LEFT Study for *Dora*, 1855–6 (no.10, p.28)

ABOVE *Dora* as illustrated in Tennyson's *Poems*, 1857 (no.51, p.40)

BELOW Sketches for George Meredith's *The Crown of Love*, 1859 (no.25, p.33)

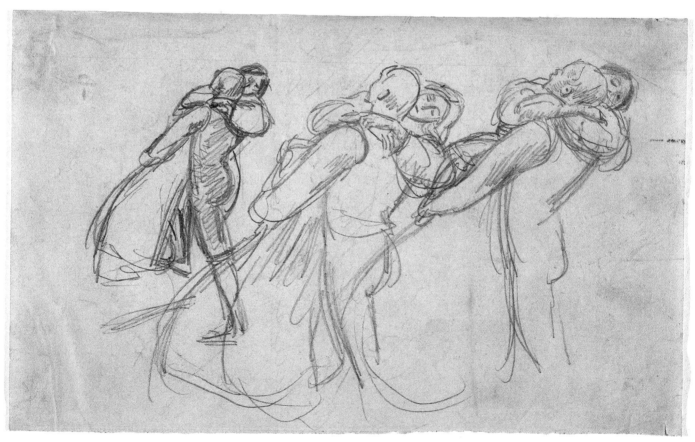

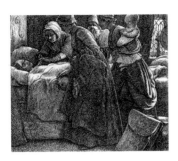

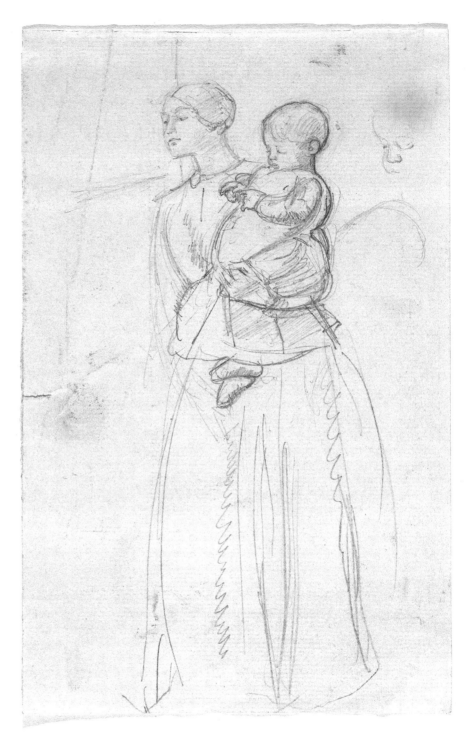

RIGHT Study for *The Lord of Burleigh –
nurse and child*, 1855–6 (no.7, p.28)

LEFT *The Lord of Burleigh* as illustrated
in Tennyson's *Poems*, 1857 (no.51, p.40)

ABOVE LEFT Sketch for Wilkie
Collins's *Mr Wray's Cash-Box*, 1851–2
(no.3, p.27)

ABOVE RIGHT Sketches for *Edward
Gray: Emma Moreland meeting Edward
Gray*, 1855–6 (no.8, p.28)

RIGHT *Edward Gray* as illustrated in
Tennyson's *Poems*, 1857 (no.51, p.40)

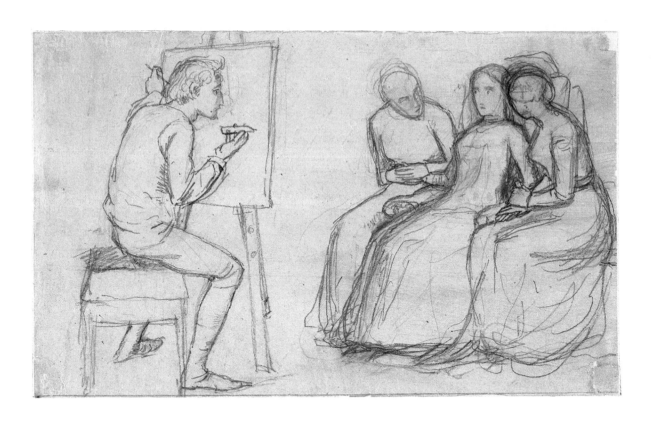

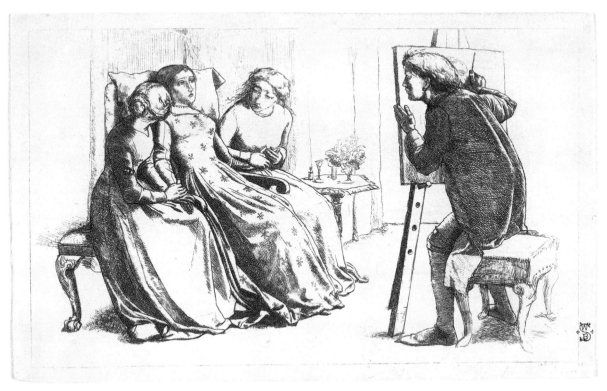

TOP Sketch for Rossetti's *St Agnes of Intercession*, 1850 (no.1, p.26)

BOTTOM Etching for *St Agnes of Intercession*, 1850 (no.2, p.26)

Watercolour version of *A Wife*,
1860–63 (no.26, p.33)

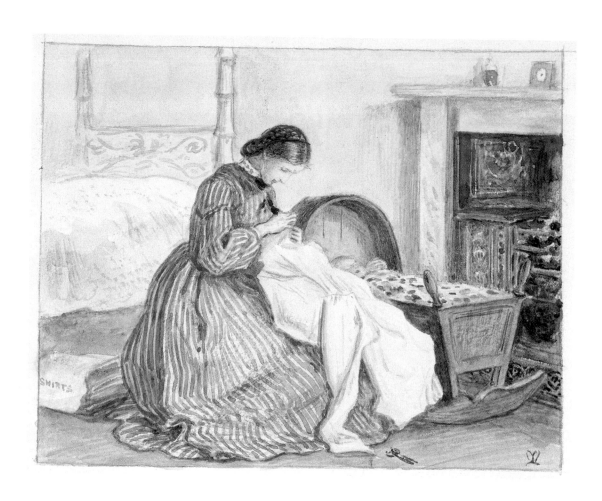

ABOVE Watercolour version of *The Seamstress*, 1860 or later (no.30, p.34)

ABOVE RIGHT Watercolour version of *The Anglers of the Dove – Farmer Chell's Kitchen*, 1862 or later (no.38, p.35)

RIGHT Wood-engraved illustration, *Farmer Chell's Kitchen*, 1862 (B163, p.66)

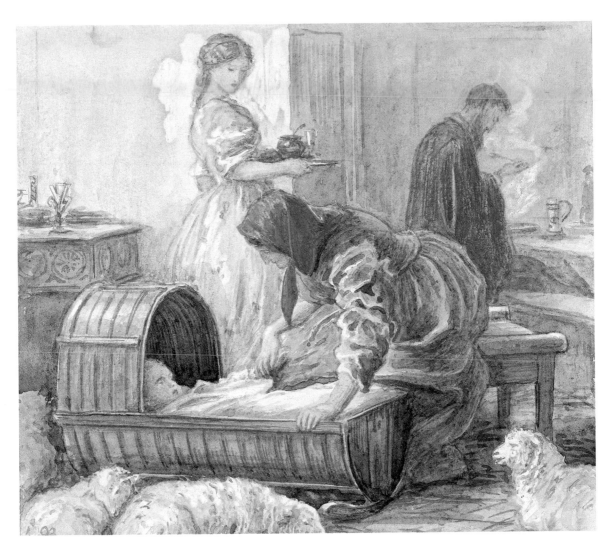

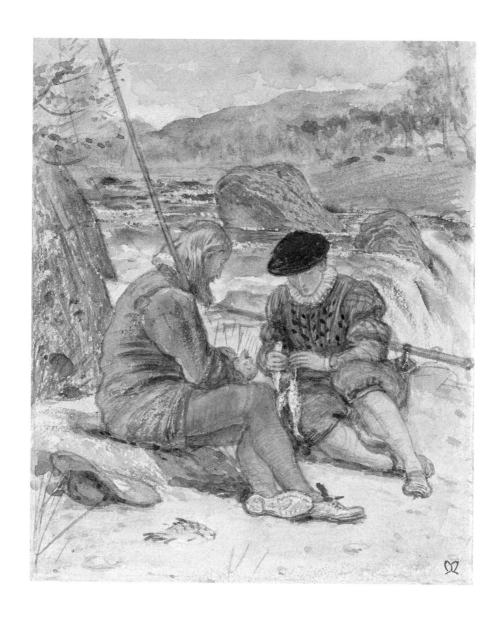

Exhibits

The exhibits are divided into two sections. The first is devoted to water-colours, drawings, wood blocks and single-sheet wood-engravings while the second contains published volumes – books or bound issues of periodicals.

The entries are ordered as follows – reference number, title of work, date, medium, size in millimetres and inches with the height being given before the width, lender, and finally museum or collection reference/accession number. At the end of the commentary references are given (where relevant) to works referred to in abbreviated form. These are generally included to give the reader information on exhibitions in which the works have been shown previously. In the case of books/periodicals the name of the author or the title appears first followed by the publisher, date, page reference, name of engraver, lender and reference/accession number.

Abbreviated References

Gere	J. A. Gere, *Pre-Raphaelite Drawings in the British Museum*, London, British Museum Press, 1994.
Hong Kong 1984	Richard Lockett, *Pre-Raphaelite Art from the Birmingham Museums and Art Gallery*, Hong Kong Museum of Art, 1984.
Jacksonville 1965	*Artists of Victoria's England*, Jacksonville, Florida, Cummer Gallery of Art, 1965.
R.A. 1967	Mary Bennett, *Millais*, Liverpool, Walker Art Gallery and London, Royal Academy of Arts, 1967.
Sidey	Tessa Sidey, *Prints in Focus*, Birmingham Museums and Art Gallery, 1997.
Warner	Malcolm Warner, *The Drawings of John Everett Millais*, Arts Council of Great Britain, Bolton Museum and Art Gallery and elsewhere, 1979.
Wildman	Stephen Wildman, *Visions of Love and Life: Pre-Raphaelite Art from the Birmingham Collection, England*, Alexandria, Virginia, Art Services International, 1995.
Wordsworth Trust, *Tennyson*, 1992	Robert Woof, *Tennyson (1809–1892): A Centenary Celebration*, Grasmere, The Wordsworth Trust, 1992.

LEFT Watercolour version of *The Anglers of the Dove – Sorting the Prey*, 1862 or later (no.39, p.36)

ABOVE Wood-engraved illustration, *The Anglers of the Dove – Sorting the Prey*, 1862 (no.40, p.36)

WATERCOLOURS, DRAWINGS AND WOOD-ENGRAVINGS

1 *Sketch for Rossetti's 'St Agnes of Intercession'*, 1850
Pencil, 109 × 175 mm (4¼ × 7 in)
Birmingham Museums and Art Gallery 1906 P625 (1)

A preparatory drawing for an etching intended for the fifth number of *The Germ* but, in the event, never published. Dante Gabriel Rossetti began the writing of a story *St Agnes of Intercession* in the spring of 1850 (at this time it was called 'An Autopsychology') and his original intention was to provide an etched illustration to accompany it. However, when he saw a proof of his own print on 28th March he declared himself dissatisfied and deliberately damaged the surface of the plate, hence ensuring that no further impression could be taken from it. It seems likely that Millais would have started work on his proposed design for the story soon after this date and certainly before 23rd May when the decision was taken to publish no further issues of *The Germ*. However, there is also the possibility that both artists might have intended to provide designs for the story so it is not entirely fanciful to suggest that Millais's drawing (and indeed the etching itself) might perhaps have been made a little earlier in 1850.

The tale is about a contemporary artist who finds that he is, in truth, the reincarnation of a fifteenth-century painter, Bucciuolo Angiolieri. The episode etched by Millais is about Bucciuolo and his lover Blanzifiore dall' Ambra, which the artist reads of in a catalogue. She becomes mortally ill in Lucca and calls for Bucciuolo to come to her side from Florence.

. . . When, on his arrival, she witnessed his anguish at thus losing her forever, Blanzifiore declared at once that she would rise from her bed, and that Bucciuolo should paint her portrait before she died; for so, she said, there should still remain something to him whereby to have her in memory. In this will she persisted against all remonstrance occasioned by the fears of her friends; and for two days, though in a dying state, she sat with wonderful energy to her lover: clad in her most sumptuous attire, and arrayed with all her jewels: her two sisters remaining constantly at her side, to sustain her, and supply restoratives. On the third day, while Bucciuolo was still at work, she died without moving.

R.A. 1967, 249, Warner, 67

2 *Etching for Rossetti's 'St Agnes of Intercession'*, 1850
Etching, 117 × 188 mm (4½ × 7¼ in) (image and paper)
Birmingham Museums and Art Gallery 1906 P625 (2)

Millais's earliest known etching and one of just three surviving impressions. The other two are in the Victoria and Albert Museum and at the Yale Center for British Art, New Haven. The Birmingham impression was given by the artist to William Bell Scott, whose collector's mark, in the form of a stamped monogram *WBS*, appears at the lower right.

Sidey, 42 (repr)

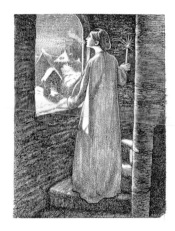

ST. AGNES' EVE.

1.

DEEP on the convent-roof the snows
 Are sparkling to the moon:
My breath to heaven like vapour goes:
 May my soul follow soon!

3 Sketch for Wilkie Collins's 'Mr Wray's Cash-Box', 1851–2
Pencil, 140 × 98 mm (5½ × 4 in) (image and paper)
Birmingham Museums and Art Gallery 1906 P590

Formerly described as a design relating to *The Miller's Daughter* and exhibited as such in the Tennyson exhibition (The Wordsworth Trust, 1992, no.257), the present sheet has recently been identified as a drawing for Millais's first published illustration. This is the frontispiece for W. Wilkie Collins *Mr Wray's Cash-Box*, Richard Bentley, 1852. Mounted with this design is another also in graphite (1906 P628) which might just be a preliminary idea for the same subject.

4 Mr Wray's Cash-Box or The Mask and the Mystery, Richard Bentley, 1852
Etching – frontispiece, 167 × 100 mm (6½ × 4 in)
Geoffroy Richard Everett Millais Collection

Annie Wray ties her lover, Martin Blunt's cravat '. . . telling him to stoop, [she] tied his cravat directly – standing on tiptoe.'

Placed as the frontispiece to the book. The design is a clear example of Millais's interest in and mastery of contemporary dress. It should be compared stylistically with the designs he made for *Edward Gray* in Tennyson *Poems*, 1857 (*The Moxon Tennyson*, no.8).

5 The Moxon Tennyson
Five designs, 1855–6, point of the brush with wash and penwork in Indian ink with some scratching out.

Mariana, 96 × 79 mm (3¾ × 3 in)
The Death of the Old Year, 97 × 83 mm (3¾ × 3¼ in)
St Agnes' Eve, 97 × 73 mm (3¾ × 3 in)
The Day-Dream; *The Sleeping Palace*, 81 × 96 mm (3¼ × 3¾ in), signed *JM* in monogram
The Lord of Burleigh, 82 × 95 mm (3¼ × 3¾ in)
Ashmolean Museum, Oxford 1958.53.1, 1958.53.2, 1958.53.3, WA 1954.58, 1958.53.4

These highly worked up designs suggest that they are probably final versions which would have been used by the engravers to prepare their blocks. Alternatively they may have been made after the wood-engravings for sale or presentation.

It seems likely that the lines of *Mariana* that Millais chooses come at the climax of the poem:

'Then', said she, 'I am very dreary,
 He will not come,' she said;
She wept, 'I am aweary, aweary,
 Oh God, that I were dead!'

For *The Death of the Old Year* Millais decides on a broodingly atmospheric image:

Full knee-deep lies the winter snow,
And the winter winds are wearily sighing:
Toll ye the church-bell sad and slow,
And tread softly and speak low,
For the old year lies a-dying.

For *St Agnes' Eve* Millais takes the opening lines as his subject:

Deep on the convent-roof the snows
Are sparkling to the moon:
My breath to heaven like vapour goes:
May my soul follow soon!

Millais chooses the following lines for his design to *The Day-Dream: The Sleeping Palace*:

The page has caught her hand in his:
 Her lips are sever'd as to speak:
His own are pouted to a kiss:
 The blush is fix'd upon her cheek.

For *The Lord of Burleigh* Millais shows the lady on her deathbed attended by her servants and her children. While the actual scene is not described by Tennyson, the closest line is:

Then before her time she died.

R.A. 1967, 351–5

6 The Moxon Tennyson

Three sketches for *St Agnes' Eve*, 1855–6, pencil
1906 P596: 129 × 88 mm (5 × 3½ in)
1906 P662: 115 × 90 mm (4½ × 3½ in) (sheet)
1906 P595: 168 × 73 mm (6½ × 3 in) (at widest point)
Birmingham Museums and Art Gallery

These drawings relate to the design in the book on page 309 of the convent staircase. Each reveals the artist experimenting with posture and design. While two of the drawings are summary, 1906 P595 is more detailed and is close to the published wood-engraving.

Wordsworth Trust, *Tennyson*, 1992, 263–5

7 The Moxon Tennyson

The Lord of Burleigh, 1855–6, pencil on pale blue paper, 181 × 113 mm (7 × 4½ in)
Birmingham Museums and Art Gallery 1906 P567

Drawn in preparation for the design engraved by the Dalziel Brothers on page 353 in the book. A study for the figure of the nurse holding the baby on the right hand side of the composition. In the engraved version the woman is leaning further forward and is wearing a cap.

Then before her time she died.

It is worth noting that Millais chooses to show the deathbed scene in preference to any more dramatic moment in the poem. The lord himself is absent from the action. Instead the emphasis is on the sadness of the death of a young mother with her baby poignantly observing.

Wordsworth Trust, *Tennyson*, 1992, 256

8 The Moxon Tennyson

Edward Gray, 1855–6, pencil, 166 × 95 mm (6½ × 3¾ in) (at widest point)
Birmingham Museums and Art Gallery 1906 P630

Related to the design engraved by John Thompson on page 340 of the book. An unusual example in Millais's drawings for illustration of the artist working from the male nude in order to work out pose.

Millais had visited Tennyson in November 1854 at Farringford in order to discuss his designs but apparently did not begin work until the summer of the following year. The lines illustrated are these:

Sweet Emma Moreland of yonder town
Met me walking on yonder way,
'And have you lost your heart?' she said;
'And are you married yet, Edward Gray?'

Sweet Emma Moreland spoke to me:
Bitterly weeping I turned away:
'Sweet Emma Moreland, love no more
Can touch the heart of Edward Gray'

Warner 71; Wordsworth Trust, *Tennyson*, 1992, 266

9 The Moxon Tennyson

The Day-Dream, 1855–6, two sketches, pencil, 85 × 99 mm (3½ × 4 in), 100 × 111 mm (4 × 4½ in) (sheet size)
Birmingham Museums and Art Gallery 1906 P629, 594

Related to the design engraved by Charles Thurston Thompson on page 323 of the book, these drawings reveal the care taken by Millais to work out exactly how he wished the image to look on the printed page. The lines illustrated are these:

And last with these the king awoke
And in his chair himself uprear'd
And yawn'd, and rubb'd his face, and spoke,
'By holy rood, a royal beard!
How say you? we have slept, my lords.
My beard has grown into my lap.'
The barons swore, with many words,
'Twas but an after dinner nap.

Wordsworth Trust, *Tennyson*, 1992, 262

10 The Moxon Tennyson

Dora, 1855–6, pencil with grey-green watercolour washes, arched top, 135 × 153 mm (5¼ × 6 in), signed in monogram bottom left and inscribed *Dora* centre
Birmingham Museums and Art Gallery 1906 P647

Engraved in reverse by John Thompson for page 219 of the book. Although clearly preparatory for the wood-engraving the sheet is unusual in that it is both signed and inscribed. Millais rarely inscribed his preparatory drawings, but the fact that he contributed this one to the Manchester Cotton Famine Relief Fund may explain his decision to identify it in this way. He regularly signed drawings made as versions of his illustrations. The lines illustrated are these:

Then they clung about
The old man's neck, and kiss'd him many times.
And all the man was broken with remorse;
And all his love came back a hundredfold;
And for three hours he sobb'd o'er William's child,
Thinking of William.

Jacksonville 1965, 38; Wordsworth Trust, *Tennyson*, 1992, 255 (repr); Wildman, 41 (repr in colour)

11 The Moxon Tennyson

A Dream of Fair Women – Queen Eleanor sucking the wound of Edward I, 1855–6, pen and Indian ink with scratching out, 82 × 95 mm (3 × 3¾ in)
Victoria and Albert Museum D 218-1903

Related to the design engraved by the Dalziel Brothers on page 161 of the book. Engraved in the same direction. The lines illustrated are:

Or her, who knew that love can vanquish Death,
 Who kneeling, with one arm about her king,
Drew forth the poison with her balmy breath,
 Sweet as new buds in Spring.

R.A. 1967, 357; Wordsworth Trust, *Tennyson*, 1992, 271

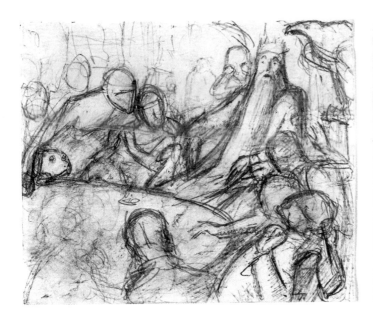
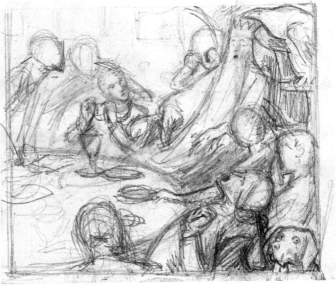

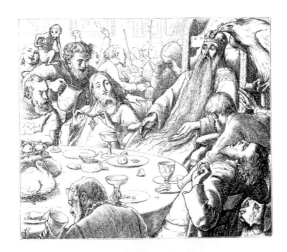

III.

And last with these the king awoke,
 And in his chair himself uprear'd,
And yawn'd, and rubb'd his face, and spoke,
 " By holy rood, a royal beard !
How say you ? we have slept, my lords.
 My beard has grown into my lap."
The barons swore, with many words,
 'Twas but an after-dinner's nap.

ABOVE Two sketches for *The Day-Dream* in Tennyson's *Poems*, 1855–6 (no.9, p.28)

RIGHT *The Day-Dream* as illustrated in Tennyson's *Poems*, 1857 (no.51, p.40)

12 The Moxon Tennyson

A Dream of Fair Women – Cleopatra, 1855–6, pen and Indian ink with scratching out, mounted with a proof wood-engraving, 94 × 82 mm (3½ × 3 in)

Proof 95 × 83 mm (3¾ × 3¼ in)

Victoria and Albert Museum D 219-1903. E2852-1914

Related to the design engraved by William James Linton on page 149 of the book. Engraved in the same direction. The lines illustrated are:

> (With that she tore her robe apart, and half
> The polish'd argent of her breast to sight
> Laid bare. Thereto she pointed with a laugh,
> Showing the aspick's bite)

R.A. 1967, 356; Wordsworth Trust, *Tennyson*, 1992, 270

13 The Good Samaritan, 1857

Pen and brown ink, pencil with pen and brown ink, 57 × 53 mm (2¼ × 2 in), 152 × 88 mm (6 × 3½ in)

British Museum, Department of Prints and Drawings, 1901-5-16-11, 12

Made for the design engraved in reverse by the Dalziel Brothers which was published initially in the periodical *Good Words* in 1863, facing page 241. It was reprinted in *The Parables of Our Lord and Saviour Jesus Christ* (Routledge, Warne and Routledge) in 1864.

Millais began work on designs for the *Parables* in 1857 and the present design is among the earliest he completed. Arguably his masterpiece in illustration, the project was never fully completed since in the end he produced only 20 designs.

Gere 150; R.A. 1967, 356, 357

14 The Young Mother, 1856–7

Etching, 205 × 160 mm (8 × 6¼ in), signed in the plate in monogram and *J.E.Millais A.R.A.* and numbered *29*

Geoffroy Richard Everett Millais Collection

In a state before letters (Victoria and Albert Museum, A 247) the print bears the date 1856. Published in *Etchings for the Art Union of London by the Etching Club*, 1857.

Millais's first child, his son Everett (d.1897) was born at Annat Lodge, Perth on 30th May 1856. If, as seems likely, the etching was made later the same year in Scotland then it is probable that the scene depicts the artist's wife, Effie, cradling Everett in a Scottish landscape.

15 The Pearl of Great Price, 1864–5

Pen and grey ink touched with watercolour, 158 × 119 mm (6 × 4¾ in), signed in monogram lower right

British Museum, Department of Prints and Drawings, 1900-4-11-6

The girl to the left is Alice Gray, the younger of Effie's two sisters.

The preparatory drawing for the subject was completed in May 1860 and Millais despatched the block on which he had drawn to the engravers, the Dalziel Brothers. On 21st May he wrote a covering letter, 'At last I have finished "The Pearl of Great Price" – you will at once see there is a tremendous lot of work in it . . . I must repeat that such drawings are the work of *days, & weeks* of arrangement – I could do them all very quickly as you can guess but not in that style.'

The highly finished nature of the sheet suggests that it is a version of the wood-engraving and hence tentatively datable 1864–5 and not a preparatory study.

> The kingdom of heaven is like unto a merchant man seeking goodly pearls: who, when he had found one pearl of great price, went and sold all that he had, and bought it. Matthew 13: 45–6

Gere, 150

16 The Marriage Feast (Parable of the Marriage of the King's Son), 1863

Pen and ink on a background of Chinese white on wood block, 135 × 105 mm (5¼ × 4 in)

Victoria and Albert Museum 1073-1884

The block is datable between 25th July 1863 when Millais wrote to his wife Effie that he was expecting models to sit for the drawing and 6th November when he wrote to the Dalziels mentioning adjustments to the proof by way of a sketch (letters in the Pierpont Morgan Library and the Huntington Library).

Millais drew for the engraver in reverse direct onto the boxwood block prepared with a surface of Chinese white, usually in ink, lampblack and occasionally graphite.

It was during 1863 that the Dalziels began to transfer photographically the designs to another block which was then cut in the normal way. As a result this block and three others, which are the final four, remain – *The Unmerciful Servant* (Museum of Fine Arts, Boston), *The Importunate Friend* and *The Good Shepherd* (Johannesburg Art Gallery). The few remaining drawn blocks by Millais demonstrate exactly what he sent to the engravers for them to work from.

The design does not illustrate Luke's *Parable of the Marriage Feast* but that of the *Marriage of the King's Son* (Matthew 22: 2-14). The host is a king and the servant is seizing the guest who is without a wedding garment. It is evident that Millais believed that this was the parable he was illustrating. When the book was published in 1864 the mistake was pointed out and some time later the Dalziel Brothers removed the text of the *Parable of the Marriage Feast* and replaced it with the *Marriage of the King's Son*. However, they neglected to change the list of contents or the caption to the illustration.

The block was bought by the Victoria and Albert Museum direct from the Dalziel Brothers in July 1884.

Warner, 77

17 Love, c.1862

Pen and ink and blue watercolour wash, probably touched with watercolour, 128 × 96 mm (5 × 3¾ in), signed in monogram

Victoria and Albert Museum 178-1894

Made in connection with the design engraved by the Dalziel Brothers on page 137 of Robert Aris Willmott (ed) *The Poets of the Nineteenth Century*, Routledge, 1857 to a poem by Coleridge.

The present sheet is a highly finished version of the wood-engraving and is tentatively identified as 'Genevieve' (the name of the lady in the poem) from an account book kept by Effie Millais (private collection) where it is dated 1862.

Forrest Reid, in his pioneering study of the subject of Victorian illustration, remarked of this design that in his opinion it was:

> . . . the most moving and impassioned he [Millais] ever made. He made many drawings which in beauty of line and form equal it, but none, it seems to me, which shows the same quality of ecstasy. This picture of two figures clinging together in a darkened landscape, with the great white moon rising between the branches of the trees, strikes us indeed as being in no way inferior to the work of Coleridge himself. (*Illustrators of the Sixties*, Faber and Gwyer, 1928, p.67).

The lines illustrated are these:

> Her bosom heaved – she stepped aside,
> As conscious of my look she stept –
> Then suddenly, with timorous eye
> She fled to me and wept

R.A. 1967, 358; Warner, 70

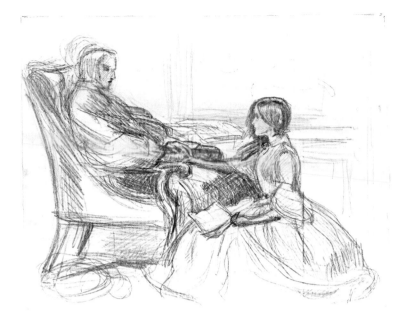

ABOVE Sketch for Tennyson's *The Grandmother's Apology*, **1859** (no.19, p.31)

RIGHT Sketch for Tennyson's *The Grandmother's Apology: Girl Seated on Floor* **1859** (no.20, p.31)

18 *The Finding of Moses*, c.1857–8

Watercolour and bodycolour, 141 × 114 mm (5½ × 4½ in), signed in monogram

Victoria and Albert Museum, Harrod Collection, E 1047-1948

Made in connection with the design engraved by the Dalziel Brothers on page 51 of *Lays of the Holy Land from Ancient and Modern Poets*, James Nisbet, 1858.

Although executed in watercolour and bodycolour and signed, which would usually suggest a version after the wood-engraving, the unfinished and lively nature of the drawing might indicate a preparatory sketch worked up later for presentation or sale. The poem is by James Grahame and is entitled *Moses on the Nile*:

> Slow glides the Nile: amid the margin flags,
> Closed in a bulrush-ark, the babe is left,
> Left by a mother's hand. His sister waits
> Far off; and pale, 'tween hope and fear, beholds
> The royal maid, surrounded by her train,
> Approach the river bank; approach the spot
> Where sleeps the innocent: She sees them stoop
> With meeting plumes; the rushy lid is oped,
> And wakes the infant, smiling in his tears, -
> As when along a little mountain lake,
> The summer south-wind breathes with gentle sigh,
> And parts the reeds, unveiling, as they bend,
> A water-lily floating on the wave.

19 *Sketch for Tennyson's 'The Grandmother's Apology'*, 1859

Pencil, 103 × 127 mm (4 × 5 in)

Birmingham Museums and Art Gallery 1906 P574

A preparatory design made for the wood-engraving by the Dalziel Brothers which was published on 16th July 1859 on page 41 of the periodical *Once a Week*. The poem is by Tennyson.

The sense of rapt intensity in the young girl's expression clearly preoccupied Millais and can be seen also in the other larger drawing of the girl alone, in the Birmingham collection (see below).

Millais's design appeared in the third number of the magazine to one of Tennyson's few contributions to it. The poem is about the grandmother musing to her granddaughter about her son's death and also about her own. The themes of the contrast between youth and age and the approach of death are central ones in Victorian literature and illustration:

> So Willy has gone, my beauty, my eldest-born, my flower;
> But how can I weep for Willy, he has but gone for an hour, -
> Gone for a minute, my son, from this room into the next;
> I, too, shall go in a minute. What time have I to be vex't?
>
> And Willy's wife has written, she never was overwise.
> Get me my glasses, Annie: thank God that I keep my eyes.
> There is but a trifle left you, when I shall have passed away.
> But stay with the old woman now: you cannot have long to stay.

20 *Sketch for Tennyson's 'The Grandmother's Apology': Girl Seated on Floor*, 1859

Pencil, 155 × 103 mm (6 × 4 in)

Birmingham Museums and Art Gallery 1906 P575

21 *La Fille Bien Gardée*, 1859

Pencil, pen and brown ink, 104 × 90 mm (4 × 3½ in), signed in monogram lower right
Ashmolean Museum, Oxford 1942.158

A drawing made in connection with the wood-engraving by Joseph Swain published in *Once a Week* on 8th October 1859, page 306. The verse is signed *S.B.* and with the address *Queen's Bar Ride, Temple*. It tells in light-hearted vein of the lover's feelings at the absence abroad of Edith:

> You'll call me such a worry, Edith, but it is not fun
> To be stuck in Temple chambers when October has begun;
> So pity for a lover who's condemned in town to stay,
> When She – and everybody else – are off and far away.

The Irish wolfhound was Millais's own dog, called Rosewell. There is a watercolour version of this subject in the Grenville Library, Winthrop Collection, Fogg Art Museum, Cambridge Mass. 1943.483.

22 *Sketch for 'The Plague of Elliant'*, 1859

Pencil, 111 × 170 mm (4½ × 6¾ in)
Birmingham Museums and Art Gallery 1906 P569

A preparatory design for the wood-engraving by Joseph Swain which was published in *Once a Week* on 15th October 1859, page 316.

A summary and vigorous sketch showing Millais working out visually how to place the bodies on the bier. The poem, translated from the original Breton by Tom Taylor, was reprinted together with Millais's design in his *Ballads and Songs of Brittany*, Macmillan, 1865. The lines which Millais illustrates are:

> Nine children of one house there were
> Whom one dead-cart to the grave did bear:
> Their mother 'twixt the shafts did fare.

R.A. 1967, 373

23 *A Lost Love*, c.1860

Watercolour and bodycolour heightened with gum arabic, 103 × 85 mm (4 × 3½ in), signed lower left in monogram
British Museum, Department of Prints and Drawings, 1937-4-10-3

Made after the wood-engraving by the Dalziel Brothers which was published in *Once a Week* on 3rd December 1859, page 482 to a poem signed *R.A.B.* A finished study of the same subject in pen and ink signed in monogram appeared in *Victorian Pictures*, The Maas Gallery, London, 4th June – 12th July 1996, no.24 (repr in colour). The catalogue entry states that Malcolm Warner saw the drawing as 'typical of the finished drawings that the Dalziels asked of their illustrators to use for reference whilst actually proofing the engravings'.

There is a likelihood that the sitter may be Alice Gray (1845–82), the younger of Effie's two sisters. The first verse of the poem reads:

> So fair and yet so desolate;
> So wan, and yet so young;
> Oh, there is quiet too deep for tears,
> Too seal'd for tell-tale tongue!
> With a faded floweret in her hand,
> Poor little hand, so white!
> And dim blue eye, from her casement high
> She looks upon the night.

Gere, 47 (repr)

24 *Sketch for Christina Rossetti's 'Maude Clare'*, 1859

Pencil, 167 × 123 mm (6½ × 4¼ in) (sheet size)
Birmingham Museums and Art Gallery 1906 P576

A preparatory design for the wood-engraving by Joseph Swain which was published in *Once a Week* on 5th November 1859, page 382. The poem is by Christina Rossetti and the relevant lines are as follows:

TOP Sketch for *The Plague of Elliant*, 1859 (no.22, p.32)

BOTTOM Sketches for Christina Rossetti's *Maude Clare*, 1859 (no.24, p.32)

Take my share of a fickle heart,
Mine of a paltry love:
Take it, or leave it, as you will,
I wash my hands thereof

25 Three Sketches for George Meredith's 'The Crown of Love', 1859
Pencil on blue paper, 130 × 208 mm (5 × 8 in), three studies on one sheet
Birmingham Museums and Art Gallery 1906 P571

Preparatory designs for the wood-engraving by Joseph Swain which was published in *Once a Week* on 31st December 1859, page 10.

An informative sheet in which each sketch of the lover ascending the hill, carrying the princess in his arms with her head on his shoulder, is attempted again with slight variations. The poem is by George Meredith:

O death-white mouth! O cast me down!
Thou diest? Then with thee I die.
See'st thou the Angels with a Crown?
We twain have reach'd the sky.

26 A Wife, 1860–63
Watercolour and bodycolour, image 96 × 121 mm (3¾ × 4¾ in), signed in monogram
Birmingham Museums and Art Gallery 1906 P656

A watercolour version of a wood-engraving by Joseph Swain published in *Once a Week* on 7th January 1860, page 32. The poem, signed *A*, is about a loveless marriage and the relevant lines are these:

Face in both hands, she knelt on the carpet;
The black cloud loosen'd, the storm-rain fell:
Oh! life has so much to wilder and warp it, -
One poor heart's day what poet could tell?

This watercolour, although relating to a design published in 1860, was probably made during the first half of 1863 before it was sold to the watercolourist Myles Birket Foster (1825–99). This is known from a letter from Millais to Effie, dated 22nd July 1863, mentioning the present sheet (New York, Pierpont Morgan Library).

Warner, 75

27 Lord Lufton and Lucy Robarts, 1860
Wood-engraving by the Dalziel Brothers, image and paper 178 × 114 mm (7 × 4½ in)
Birmingham Museums and Art Gallery 1978 P618 (1)

Published in the *Cornhill Magazine* in April 1860, facing page 449 to Anthony Trollope's *Framley Parsonage*. The scene depicted is the one in which Lord Lufton meets Lucy Robarts for the first time: 'Now we may say she was fairly caught, and Lord Lufton, taking a pair of pheasants from the gamekeeper, and swinging them over his shoulder walked off with his prey.'

28 Was it not a Lie? 1860
Wood-engraving by the Dalziel Brothers, image and paper 182 × 127 mm (7 × 5 in)
Birmingham Museums and Art Gallery 1978 P618 (2)

Published in the *Cornhill Magazine* in June 1860, facing page 691 to Anthony Trollope's *Framley Parsonage*. The scene depicted by Millais is a most dramatic one. Lucy Robarts has just rejected Lord Lufton's proposal of marriage. She is unable to voice her true feelings:

And when he was well gone – absolutely out of sight from the window – Lucy walked steadily up to her room, locked the door, and then threw herself on the bed. Why – oh! Why had she told such a falsehood? Could anything justify her in a lie? Was it not a lie – knowing as she did that she loved him with all her loving heart?

Wood-engraved illustration, *Was it not a Lie*, 1860 (no.28, p.33)

29 Violet, 1860

Pen and brown ink, 82 × 65 mm (3 × 2½ in), inscribed lower right *from* and signed in monogram
Robin de Beaumont

Related to the wood-engraving by Joseph Swain which was published in *Once a Week* on 28th July 1860, page 140. The poem is by Arthur J. Munby. Robin de Beaumont has identified the sitter as Effie Millais (Gray) (1828–97), the wife of the artist, from an album of proofs in the British Museum which had belonged to the artist. The proof is annotated with the date 1855 (BM 1992-4-6-297 [41]).

The present drawing may have been the finished example employed to help the engraver at proofing stage. However, the monogram and the inscription suggest that it was at some time made ready for presentation by the artist.

The poem is about a girl meeting her lover in order to tell him that they must separate. She presents him with a violet because it was 'meant for those who never can forget'. The verses referred to are the following:

> She stood, where I had used to wait
> For her, beneath the gaunt old yew,
> And near a column of the gate
> That opened on the avenue . . .
>
> And she, impressing half the sole
> Of one small foot against the ground
> Stood resting on the yew-tree bole
> A-tiptoe to each sylvan sound

Warner, 81

30 The Seamstress, 1860 or later

Watercolour, 112 × 138 mm (4½ × 5½ in) (sheet), 101 × 128 mm (4 × 5 in) (image), signed in monogram lower right.
Birmingham Museums and Art Gallery 1906 P655

A version made after the design to a story by J. Stewart Harrison called *The Iceberg*, which was published in *Once a Week* on 6th October 1860, page 407.

The story tells how a sailor (Ben) who is attached to the young woman (Esther) returns from a voyage to discover that she has borne a son by another man. He enters the room:

> In short, she was ruined, and had run away. I went nearly mad at this, and set out to find her, and after about three months I found her at Manchester. I didn't go into her place at first, but asked some questions about her in the neighbourhood, and found she'd got a child – a boy – and was working at shirt-making for a living, and was quite a decent woman. I knew she'd have died rather than be what some would have turned to in her case. So I went up and saw her. She was dreadfully thin, and her eyes bright and far back in her head. The baby was lying in a cradle by the fire – such a little bit it hardly kept the room warm.

A highly finished example of a watercolour made by Millais after the wood-engraving for sale. It was sold to the watercolourist Myles Birket Foster apparently before July 1863 and later belonged to Charles Fairfax Murray.

In the story, a moment after Ben sees Esther sewing she faints. However, Millais shows here that he does not invariably choose to depict a moment of high drama in his illustrations. Instead there is here a moment of deep concentration just before a significant action.

Wildman, 53 (repr)

31 Iphis and Anaxarete, 1861 or later

Watercolour and bodycolour, 80 × 133 mm (3 × 5 in), signed in monogram lower right
Ashmolean Museum, Oxford 1940–57

A version of the wood-engraving by Joseph Swain which was published in *Once a Week* on 19th January 1861. The poem is by Mary Münster:

> Silence fell.
> The sad low voice was hushed, and the night waned,
> Till o'er the hill-tops came the shivering dawn,
> And the stars melted in the bright'ning skies.
> But when the east was robed to greet the sun
> With gold and crimson, up the stony street
> Came glad young voices and impatient feet
> To greet the destined bride; and when they came
> They found what *had been* Iphis, and *was* now
> A ghastly thing to pale the brightest cheek,
> And haunt the dreams of many a night to come.

32 'Mark', she said 'The men are here', 1861

Pen and brown ink and watercolour, 249 × 176 mm (9¾ × 7 in), signed in monogram and dated 1861 in red
Birmingham Museums and Art Gallery 1906 P648

A design related to the wood-engraving engraved by the Dalziel Brothers which was published in the *Cornhill Magazine* in March 1861 to *Framley Parsonage* by Anthony Trollope, facing page 342. The scene depicted occurs on page 352, where Fanny Robarts tells her husband that the bailiffs are at the door intent on reclaiming Framley Parsonage.

> 'They are in the yard'. 'I know it,' he answered gruffly.
> 'Will it be better that you should see them, dearest?'
> 'See them; no; what good can I do by seeing them?'

Because of the highly finished nature of the drawing it is likely to be a version made for sale rather than preparatory to the wood-engraving.

33 Tannhaüser, 1861

Pencil on boxwood, uncut, 115 × 95 × 23 mm (4½ × 3¾ × 1 in)
Geoffroy Richard Everett Millais Collection

Related to the wood-engraving by Joseph Swain published in *Once a Week* on 17th August 1861, page 211.

Comparatively few drawings by Millais on wood blocks remain in existence. Two for subjects in *The Parables of Our Lord* (1863–4) are in the collections of the Johannesburg Art Gallery and a third for the same project is in the Victoria and Albert Museum. A fourth in the group is in Boston (Museum of Fine Arts).

Most of the blocks on which Millais drew direct were cut by the engraver and, although retained for many years for the process of proofing, they were eventually discarded. The present block and another also shown here (see no.41), hitherto unexhibited, are of particular interest because both show the artist working out ideas for designs direct onto wood. Neither was engraved in the event and the final published designs differ considerably from these two blocks.

34 Tannhaüser, 1861

Wood-engraving by Joseph Swain, image 113 × 93 mm (4½ × 3½ in)
Birmingham Museums and Art Gallery 1978 P619 (10)

Published in *Once a Week* on 17th August 1861, page 211, to a poem translated from an old ballad signed *L.D.G.*:

> Your cherry lips avail me nought:
> I loathe them from my heart!
> In the name of all women's honour, I pray
> You'll give me leave to part.

35 Irené, 1862

Wood-engraving by Joseph Swain, image 174 × 115 mm (6¾ × 4½ in)
Birmingham Museums and Art Gallery 1978 P620 (11)

Published in the *Cornhill Magazine* in April 1862, facing page 478 to a poem signed *RM*.

Irené hears, for every spirit breath
That flits abroad is by Irené hearkened;
And, reverent, she has knelt as mute as death
Beside the window since her chamber darkened.

36 *Sister Anna's Probation*, 1862 or later

Watercolour, 120 × 130 mm (4¾ × 5 in) (image), signed in monogram.
Birmingham Museums and Art Gallery 1927 P901

A version of the wood-engraving by Joseph Swain which was published in
Once a Week on 12th April 1862, page 421. The story is by Harriet Martineau
and the scene depicted occurs at the conclusion in which the lovers, Anna
and Henry, are reunited.

> . . . and they were soon hidden in the wood, their horses tied to trees . . .
> The volume was there – untouched since Anna had read in it last. She
> showed what her last lesson had been: and then they took out their
> precious book, hiding away in its four-legged case. They lived to have a
> handsome family Bible, in a place of honour in their own hall: but to the
> end of their days this was the Bible from which they read together.

R.A. 1967, 376

37 *Sister Anna's Probation (Anna and Henry are united)*, 1862

Wood-engraving by Joseph Swain, image 114 × 128 mm (4½ × 5 in)
Birmingham Museums and Art Gallery 1978 P621 (1)

Published in *Once a Week* on 12th April 1862 to the story by Harriet Martineau.

38 *The Anglers of the Dove: Farmer Chell's Kitchen*, 1862 or later

Watercolour, sheet size 131 × 145 mm (5 × 5¾ in), signed in monogram
Birmingham Museums and Art Gallery 1931 P42

A version of the wood-engraving by Joseph Swain published in *Once a Week*
on 19th July 1862, page 85, to the story by Harriet Martineau.

Millais chooses a scene of the Chell family at home. As with many of his
designs which are uncaptioned in the magazine, the actual moment he depicts
is frequently separated from the image by several pages. Here, for example,
the action takes place on page 89:

> Polly was wanted at home, – sorely wanted. Her father was in from the
> field; her mother was weary with the tending of the ewes, and had brought
> in two or three half alive lambs, which began to make a noise as the
> warmth of the chimney corner revived them. The good wife remarked that
> they had made her neglect her own dear lamb; and she leaned over the crib
> in which lay her sick child, quietly crying because the noise prevented him
> from sleeping.

In the entry for this design in the Royal Academy exhibition in 1967 there
was mention of white heightening. However, it now appears that Millais used
the white of the paper to produce this effect and may indeed have scratched
out to the surface beneath.

R.A. 1967, 377; Hong Kong 1984, 39 (repr)

39 *The Anglers of the Dove: Sorting the Prey*, 1862 or later
Watercolour and bodycolour, 144 × 116 mm (5¾ × 4½ in) (image), signed in monogram
Birmingham Museums and Art Gallery 1926 P1

A version of the wood-engraving by Joseph Swain published in *Once a Week* on 26th July 1862, page 113, to the story by Harriet Martineau.

> *Stansbury and Felton sort their catch*
> The party sat down to sort their prey. The finest were taken charge of by Sampson, who marched off with the pannier on his shoulder. The gentlemen amused themselves with stringing the rest on birch twigs and long rushes.

An expert use of the white paper as a heightening agent for the water in the river and elsewhere in this most accomplished sheet.

40 *The Anglers of the Dove: Sorting the Prey*, 1862
Wood-engraving by Joseph Swain, image 127 × 98 mm (5 × 4 in)
Birmingham Museums and Art Gallery 1978 P625 (6)

Published in *Once a Week* on 26th July 1862, page 113, to the story by Harriet Martineau.

41 *Mistress and Maid*, 1862
Pencil on boxwood, uncut, 152 × 114 × 23 mm (6 × 4½ × 1 in)
Geoffroy Richard Everett Millais Collection

A design related to the wood-engraving by the Dalziel Brothers which was published in September 1862, on page 545 of *Good Words*, to the story by Dinah Mulock (Mrs Craik). A rare survival of a drawing by Millais on a block which was not engraved (see also no.33). Hilary ponders over whether Ascott Leaf has committed suicide:

> Nevertheless, in spite of herself, while she and her sisters sat together, hour after hour, in a stillness almost like that when there is a death in the house, these morbid terrors took a double size. Hilary ceased to treat them as ridiculous impossibilities, but began to argue them out rationally. The mere act of doing so made her recoil; for it seemed an acknowledgement that she was fighting not with chimeras, but realities.

An example of Millais deliberately declining to illustrate an obviously dramatic moment, preferring instead to focus on mood and atmosphere.

42 *Please, Ma'am, can we have the peas to shell?*, 1862
Wood-engraving by the Dalziel Brothers, image 164 × 103 mm (6½ × 4 in)
Birmingham Museums and Art Gallery 1978 P623 (3)

Published in the *Cornhill Magazine* in September 1862 to Anthony Trollope's *The Small House at Allington*. The scene depicted occurs when Mrs Dale, pondering over what her daughter Lily has just said to her, is interrupted by the maid: 'And then she repeated to herself the words which Lily had spoken, sitting there, leaning with her elbow on her knee, and her head upon her hand. "Please, Ma'am, cook says, can we have the peas to shell?" and then her reverie was broken.'

43 *O the Lark is Singing in the Sky*, 1864
Wood-engraving by Joseph Swain, image 148 × 112 mm (5¾ × 4½ in)
Birmingham Museums and Art Gallery 1978 P620 (9)

Published in *Good Words* January 1864, facing page 64. The poem is signed *R.B.R.*

> O the lark is singing in the sky,
> A bonny, bonny song;
> But there's a bird in my heart, love,
> A-singing all day long.
> The soaring lark sinks back to earth –

TOP LEFT Wood-engraved illustration, *The Anglers of the Dove – Sorting the Prey*, 1862 (no.40, p.36)

BOTTOM LEFT Wood-engraved illustration, *O the Lark is Singing in the Sky*, 1864 (no.43, p. 36)

RIGHT Wood-engraved illustration, *Please Ma'am, can we have the peas to shell?*, 1862 (no.42, p.36)

His song will soon be o'er;
But the bird in my heart, love,
Shall sing for evermore.

44 Dalziel's Arabian Nights Entertainments, 1864–5
Wood-engravings, 170 × 128 mm (6¾ × 5 in), 167 × 124 mm (6½ × 5 in)
Zobeidè discovers the young man reading the Koran, 1864
Aminè and the Lady, 1864
British Museum Department of Prints and Drawings 1913-4-15-179 (59, 61)

Two proof wood-engravings by the Dalziel Brothers which have been touched by the artist with Chinese white and a trace of blue watercolour. When a block had been cut by the engraver the normal practice was to send proofs to the artist for approval or, as in this case, for correction. The delicacy and meticulousness shown here reveal the care Millais took over seemingly minute gradations of tone and line.

Dalziel's Arabian Nights Entertainments was initially published in 21 monthly parts between January 1864 and September 1865. Millais's two contributions appeared in March 1864 and the book itself appeared in 1865 in two volumes from Ward, Lock and Tyler. The majority of the illustrations were the work of Arthur Boyd Houghton (1836–75). The first design appears on page 97 and the second on page 105. The scene described in the first design is as follows:

I perceived, also, a small carpet, spread out in the same manner as those which we are accustomed to kneel upon when we pray. A young man, of a pleasant countenance, was seated upon this carpet, reading aloud, with great attention from the Koran which lay before him on a small desk. Astonished and delighted at this sight, I endeavoured to account to myself for the astonishing fact that he was the only person alive in a town where everyone else was petrified, and I felt sure that there was something very extraordinary in this.

The scene described in the second design is as follows: 'My guide conducted me through a court into a large hall, where I was received by a young lady of incomparable beauty. She immediately came towards me; and after embracing me, she made me sit next to her on a sofa, over which there was a sort of throne, or canopy, formed of precious wood enriched with diamonds.'

THE MEMOIRS OF BARRY LYNDON, 1879

45 Barry Lyndon's First Love, 1878–9
Pen and ink with white bodycolour, 233 × 170 mm (9 × 6¾ in) (sheet size), signed in monogram and dated *1879*
Birmingham Museums and Art Gallery 1906 P657

A drawing related to the wood-engraving by Joseph Swain which was published in Thackeray's *The Memoirs of Barry Lyndon* from Smith, Elder's de luxe edition of the complete works of the author, volume 19, facing page 18. The high degree of finish suggests that the drawing was the final one approved by the artist to be engraved.

The date seems to have been added by Millais at a later date since it is done in a different coloured ink. This is perhaps explained by the fact that Millais lent this drawing (and three others related to the same book, of which two other Birmingham drawings are also included here, see nos 46–8) to an exhibition at the Grosvenor Gallery in 1886 – *Works by Sir John Everett Millais, Bt, R.A.* (141, 2 or 3).

Barry Lyndon dallies with Honoria Brady (Nora)
In the course of our diversion Nora managed to scratch her arm, and it bled, and she screamed, and it was mighty round and white, and I tied it up, and I believe I was permitted to kiss her hand.

Hong Kong 1984, 40 (repr)

46 Barry Lyndon's First Love, 1878–9
Pen, ink and grey wash, 155 × 106 mm (6 × 4 in); pencil, 155 × 44 mm (6 × 1¾) in

Geoffroy Richard Everett Millais Collection

One of these two drawings is clearly preparatory for the subject. The other may indeed be a preliminary thought for the identical composition. However, both designs show Millais's sensitive feeling for costume of almost any age. His drawing of Nora's dress, although relatively summary, is executed with remarkable skill and is full of life. It might well be compared stylistically with some of the drawings in coloured chalks (aux trois crayons), made of women, by Jean Antoine Watteau (1684–1721).

47 The Intercepted Letters, 1878–9
Pen and ink with white bodycolour, 198 × 158 mm (7¾ × 6¼ in), signed in monogram and dated *1879*.
Birmingham Museums and Art Gallery 1906 P658

Related to the wood-engraving by Joseph Swain published in Thackeray's *The Memoirs of Barry Lyndon* (see nos 45–6, 48), facing page 207.
Another highly finished drawing again signed and probably dated later for inclusion in the Grosvenor Gallery exhibition of 1886.

My Lady Lyndon's letters were none the worse for being opened, and a great deal the better; the knowledge obtained from the perusal of some of her multifarious epistles enabling me to become intimate with her character in a hundred ways, and obtain a power over her by which I was not slow to profit.

48 Study for 'Barry Lyndon's Last Days', 1878–9
Pen and ink with white bodycolour, 201 × 155 mm (8 × 6 in), signed in monogram and dated *1879*
Birmingham Museums and Art Gallery 1906 P659

Made in connection with the wood-engraving by Joseph Swain for Thackeray's *The Memoirs of Barry Lyndon* (see also nos 45–7). Another drawing presumably signed and dated by Millais for inclusion in the 1886 Grosvenor Gallery exhibition.

Stylistically these drawings for Thackeray are interesting since they reveal Millais drawing in a far tighter and more Georgian style than before, prefiguring the work of illustrators of the next period, notably Hugh Thomson (1860–1920) and the brothers Charles Edmund (1870–1938) and Henry Matthew (1875–1960) Brock.

Barry Lyndon sits with his mother in prison: 'She is very old, and is sitting by my side at this moment in the prison, working: she has a bedroom in Fleet Market over the way; and, with the fifty-pound annuity, which she has kept with a wise prudence, we manage to eke out a miserable existence, quite unworthy of the famous and fashionable Barry Lyndon.'

Forrest Reid deemed this image a 'masterpiece' and remarked, 'The drawing of that drunken figure seated at the table is the most realistic and the most terrible design Millais ever made.' (*Illustrators of the Sixties*, Faber and Gwyer, 1928, p.79)

49 A Penny for her Thoughts, 1878
Pencil, 252 × 175 mm (10 × 7 in)
Geoffroy Richard Everett Millais Collection

A drawing from a sketchbook dated 1878 and preliminary for the etching published in 1879.

50 A Penny for her Thoughts, 1878
Etching, 252 × 185 mm (10 × 7¼ in), signed *J. E. Millais* in pencil lower left within platemark
Geoffroy Richard Everett Millais Collection

Executed in 1878 but published by The Etching Club in 1879. Geoffroy Millais is confident that the subject is the artist's second daughter, Mary Hunt Millais (1860–1944).

THE PEARL OF GREAT PRICE.

Wood-engraved illustration, *The Pearl of Great Price*, pub. 1864 (no.57, p.40)

EDWARD GRAY.

Sweet Emma Moreland of yonder town
Met me walking on yonder way,
"And have you lost your heart?" she said;
"And are you married yet, Edward Gray?"

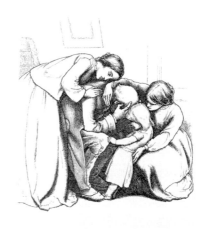

DORA. 219

And for three hours he sobb'd o'er William's child,
Thinking of William.
 So those four abode
Within one house together; and as years
Went forward, Mary took another mate;
But Dora lived unmarried till her death.

ABOVE LEFT AND RIGHT *Edward Gray* and *Dora* in Tennyson's *Poems* 1857 (no.51, p.40)

PUBLISHED BOOKS AND PERIODICALS

51 Tennyson, *Poems*, Edward Moxon, 1857
(*The Moxon Tennyson*), first edition
Page 353, *The Lord of Burleigh*, wood-engraving by the Dalziel Brothers, see related drawing no.7
Birmingham Museums and Art Gallery 1978 P203

52 Tennyson, *Poems*, Edward Moxon, 1859
(*The Moxon Tennyson*), reprint
Page 309, *St Agnes' Eve*, wood-engraving by the Dalziel Brothers, see related drawings nos 5, 6
Birmingham Reference Library A. 821.81

53 Robert Aris Willmott (ed), *The Poets of the Nineteenth Century*,
George Routledge and Co, 1857, first edition
Page 137, *Love*, wood-engraving by the Dalziel Brothers, see related drawing no.17
Birmingham Reference Library A. 821.708

54 *Once a Week*, Volume 1, 1859
Page 41, *The Grandmother's Apology*, wood-engraving by the Dalziel Brothers, see related drawings nos 19, 20
Birmingham Reference Library BO 52

55 *Good Words*, 1862
Frontispiece, wood-engraving by the Dalziel Brothers
Untitled design to Mrs Craik's *Mistress and Maid*, showing Elizabeth mourning Tom in the churchyard, a scene which comes at the end of the story
Birmingham Reference Library BO 52

56 *Millais's Collected Illustrations*, Cassell, Petter and Galpin (undated).
A reprint of the book first published by Alexander Strahan in 1866
Title page, wood-engraving by Joseph Swain
Birmingham Reference Library GQ 741.942

The book contains a selection of Millais's wood-engravings not, as might be assumed from the title, all his designs. This particular volume was acquired through the bequest of J. R. Holliday in 1927.

57 *The Parables of Our Lord and Saviour Jesus Christ*, Society for Promoting Christian Knowledge, [1885]. A reprint of the book first published in 1864 by Routledge, Warne and Routledge
Page 37, *The Good Samaritan*, wood-engraving by the Dalziel Brothers, see related drawing no.13
Birmingham Museums and Art Gallery 1970 P47

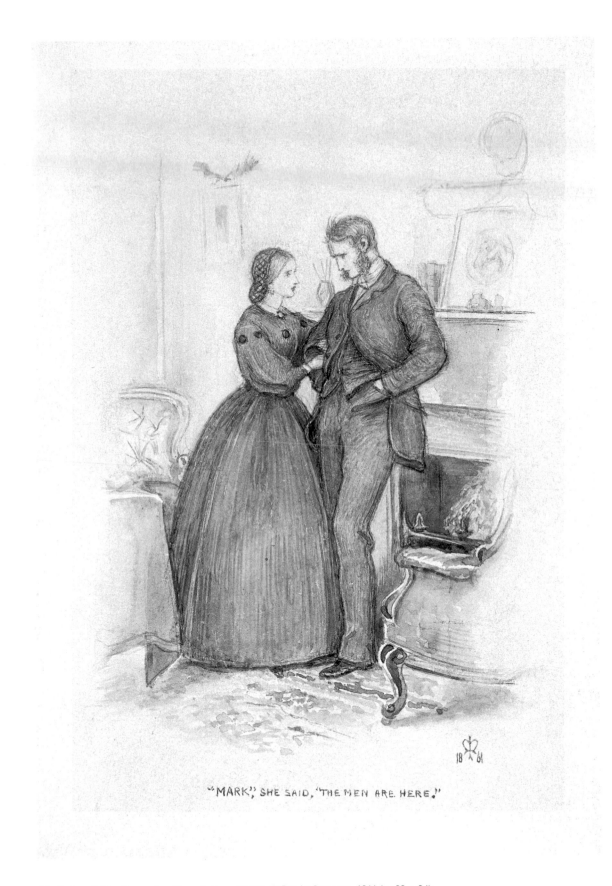

'Mark' she said 'The Men are here' from Anthony Trollope's *Framley Parsonage*, 1861 (no.32, p.34)

ABOVE Watercolour version of *Sister Anna's Probation*, 1862 or later (no.36, p.35)

LEFT Wood-engraved illustration, *Sister Anna's Probation*, 1862 (no.37, p.35)

RIGHT Study for *'Barry Lyndon': Barry Lyndon's First Love*, 1878–9 (no.45, p.38)

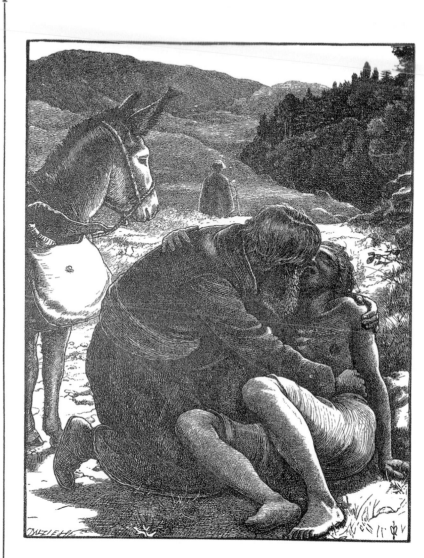

THE GOOD SAMARITAN.

Wood-engraved book illustration, *The Parables of our Lord: The Good Samaritan*, first published 1864 (no.57, p.40)

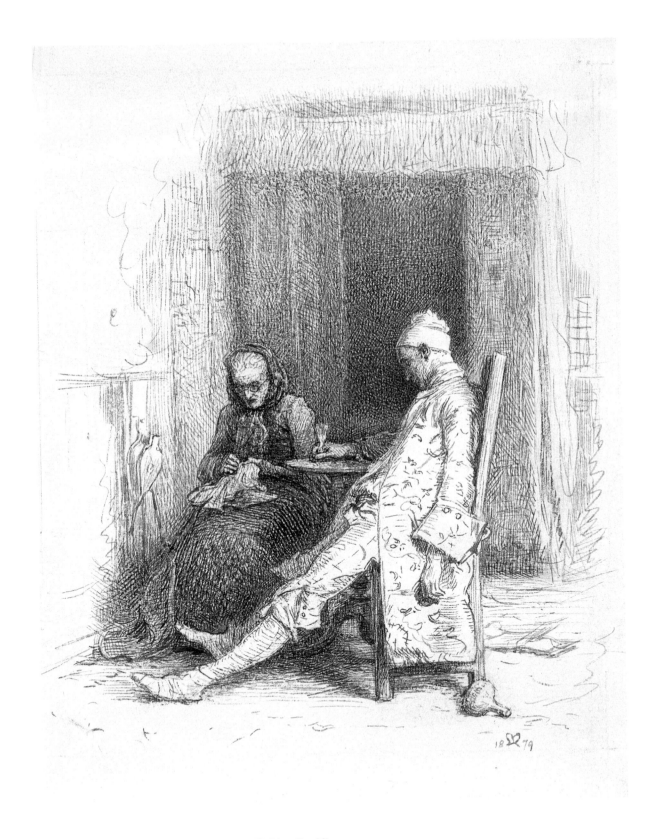

Study for 'Barry Lyndon': Barry Lyndon's Last Days, 1878–9 (no.48, p.38)

Study for 'Barry Lyndon': The Intercepted Letters, 1878–9 (no.47, p.38)

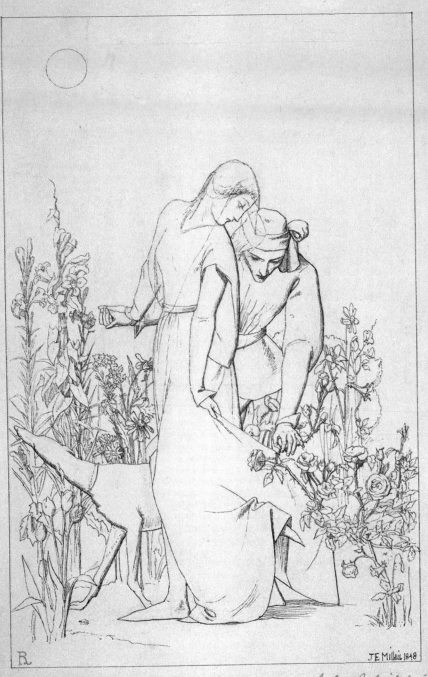

Lovers by a Rosebush, 1848 (B14, p.56)

Charles Fairfax Murray, J. R. Holliday and the Birmingham Collection of Millais Drawings

TESSA SIDEY

In May 1903 Birmingham Museum and Art Gallery received the first of an extraordinary two-phase donation of Pre-Raphaelite drawings. The source was a group of Birmingham subscribers who, led by the solicitor James Richardson Holliday,[1] provided funds to buy 547 drawings by Dante Gabriel Rossetti and Edward Burne-Jones from the collection of Charles Fairfax Murray (1849–1919).[2] The second gift in July 1906, from the same source, numbered 515 drawings by Ford Madox Brown, Frederick Sandys and John Everett Millais.[3] This focus on a near-contemporary collection of English drawings was unprecedented for a regional, or any, museum at this time. It remains the most important collection of Pre-Raphaelite drawings and the largest museum holding of Millais drawings and prints.

As a category of material, drawing registered low on the list of priorities when the museum first opened in 1885. The initial Pre-Raphaelite connection in the city came through the loan of major paintings to the local society of artists as early as 1849 and continuing into the 1880s. A generation of collectors and patrons, notably William Kenrick, John Throgmorton Middlemore and John Charles Holder, began to emerge in the 1870s,[4] with Millais himself becoming president of the now named Royal Birmingham Society of Artists in 1881–2, followed by Burne-Jones in 1885. It was this civic interest which the new keeper of the art gallery, Whitworth Wallis, galvanised into forming a Pre-Raphaelite collection.

The perennial difficulty of securing purchases, as well as donations, was given a significant boost by the staging of a major loan exhibition of Pre-Raphaelite paintings in 1891.[5] The aim of creating 'the best centre in the world in which to study this distinctively English art'[6] now linked Birmingham to a network of artists, associates and collectors. Charles Fairfax Murray in particular would have seen the museum and its keeper-director as allies in his self-designated role as 'Keeper of the Pre-Raphaelite flame'.[7]

Fairfax Murray was himself a considerable draughtsman. His abilities as a copyist secured the praise and patronage of John Ruskin and William Morris, and entrance into the Pre-Raphaelite circle in 1866 as the first studio assistant of Burne-Jones. He also, by the late 1860s, supplemented his income by buying and selling old master paintings and drawings. The American J. Pierpont Morgan figured among his clients. More personally, and largely from the 1880s when the prices were low, he

TOP LEFT Study for *Romeo and Juliet*, 1848 (B15, p.56)

BOTTOM LEFT Study for *Ophelia*, 1852 (B38, p.58)

49

began to collect Pre-Raphaelite drawings from the main auction houses and dealers in London: 'He would buy in bulk folders of things and then weed out to get a particular item'.[8] Studio sales after the artist's death were a favoured haunt, but Fairfax Murray also made the most of his close connections with the Pre-Raphaelites when a suitable occasion arose:

> I took Mr Jones an illuminated choral book in exchange for a book of studies by EBJ and by this I became possessed of over 280 drawings by the master, mostly studies done between 1865 and 1870 for the St George series for Birket Foster, Theophilius and the Angel, SKM dining room windows, the Pater 'Circe' and many others, also a few drawings from the collection.[9]

Millais was the least familiar of the leading members of the brotherhood, who Fairfax Murray may not have even met. Surviving evidence, however, indicates that he included Millais on his list of artists to collect, from at least 1886.[10] Actual purchases of drawings appear to have been made later, probably from the Millais family and certainly from the 1901 Fine Art Society *Exhibition of Pictures, Drawings and Studies for Pictures made by the late Sir J. E. Millais Bart, P.R.A.*[11] At the end of his life Fairfax Murray also owned at least four important paintings by Millais which he sold at Christie's in December 1917.[12]

The Fine Art Society exhibition was significant as it marked a relatively rare occasion when drawings by Millais appeared on the market. Essentially he did not sell his own drawings, the exception being finalised designs for wood block illustration and watercolour versions of engraved illustrations. The drawings that did change hands in his lifetime, through Christie's, tended to be those he had personally given away or the watercolours he had sold.[13] John Guille Millais credits his mother, Effie, with salvaging the remaining material that accumulated over the years, 'which she placed in books, and in most cases carefully titled and dated, whenever she succeeded in rescuing them from her husband's studio'.[14] On Millais's death in 1896, most of these drawings and sketches remained in the family, with his third and fourth sons the notable beneficiaries.[15]

Taking advantage of the few opportunities available and wearing his historian hat, Fairfax Murray's skill (intentional or not) appears to have been to avoid being selective about Millais's approach to drawing. The range of the collection sold to Birmingham is by extension fairly representative: from early copies after the old masters and armoury in the Tower (B3–12), the stylised angularity of 1848 as seen in *Lovers by a Rosebush* (B14), to the close naturalism of *Ophelia* (B38); the numerous trial and error figure arrangements for book and periodical illustrations dating from the mid 1850s, subtle watercolour versions, and a late group of studies of key narrative moments for *Barry Lyndon* (B135–7).

Officially Fairfax Murray was in contact with Birmingham Museum and Art

Gallery in 1898, if not before, when the Public Picture Gallery Fund purchased his watercolour copy of Carpaccio's *St George and the Dragon* originally produced for Philip Webb.[16] In the same year he gave the first of 33 stained glass cartoons by Burne-Jones as well as Morris's *Adoring Angels*, followed over the next six years by further cartoons and drawings by Frederick Sandys, Burne-Jones, Albert Moore, Arthur Hughes and Morris, and George Price Boyce's *Thorpe Derbyshire*.[17] These gifts, only surpassed by future donations to the Fitzwilliam Museum in Cambridge, suitably paved the way for the transactions of 1903 and 1906.

The asking price for the first group of drawings was £4,000, the equivalent today of around £25,000, but well below the market price for over 500 drawings.[18] For any museum it nevertheless represented a massive undertaking, especially for one depleted of purchase funds. The two-pronged approach would have helped alleviate this situation, although there is an indication that Fairfax Murray himself wanted to retain certain items.[19] To secure the funds, Whitworth Wallis turned to his friend James Richardson Holliday. The choice was apt as Holliday was on two key committees: the Museum and Art Gallery Committee and the Public Picture Gallery Fund. He knew Fairfax Murray: both were collectors who shared an interest in early manuscripts, as well as fine printed books and drawings, most particularly that of the Pre-Raphaelites.[20] They were also connected, perhaps most significantly, through William Morris, Fairfax Murray being mentored by Morris at the beginning of his career in 1866. Another mutual friend, Sydney Cockerell, director of the Fitzwilliam Museum and former secretary to the Kelmscott Press, continued the Morris association, later acting as an executor of Holliday's will.

As fundraiser, Holliday approached friends and associates in Birmingham who were all active supporters of the Museum. They were asked for individual donations, which it was finally decided to acknowledge collectively under the title of subscribers. At the same time there was little attempt to withhold the names of individual contributors, as seen in the official letter by Holliday to the Lord Mayor in May 1903 and where Fairfax Murray, preferring anonymity, is notably absent, 'On behalf of the Right Hon W(illiam) Kenrick, Mr C(harles) A(lston) Smith-Ryland, Mr John Feeney and Mr Cregoe Colmore as well as myself, I wish to offer for presentation to the Corporation, as a gift to the Art Gallery, a collection of drawings and studies which will be acquired for that purpose . . .'[21] Three years later a similar letter recorded a different group of subscribers: Alderman William Cadbury, Mrs Charles Dixon, G. Hookham, Sir George Kenrick, Francis William Victor Mitchell, John Palmer Phillips, Richard Pinsent and an anonymous donor. The price for this second collection has not as yet been traced but would have been proportionately less than the figure paid for the larger 1903 purchase.

Like Fairfax Murray, Holliday's own bequest of 1927 singled out Birmingham and the Fitzwilliam Museum as the main museum beneficiaries of his collection. Over

1,400 art items were received by the former, with outstanding drawings and watercolours by David Cox, Burne-Jones and Robert Hills, and Morris stained glass panels. This bequest also included a volume of 86 designs for *Cupid and Psyche* by Burne-Jones which, complete with *ex libris* labels, provides tangible evidence that Holliday actually purchased directly from Fairfax Murray.[22] Millais was represented by ten drawings and a related black and white illustration collection, 'designs by various artists for *Once a Week*'.[23]

Surviving museum correspondence from Sydney Cockerell to the new keeper at Birmingham, S. C. Kaines Smith, provides an insight into how this important bequest was selected, 'All being well a big batch of drawings will have reached the Gallery this morning. Will you kindly go through them and provisionally select what would be suitable for your Gallery . . .'[24] Lack of opportunity again probably contributed to Holliday acquiring relatively few Millais drawings. There is little doubt, however, as to the value that he placed on this artist as a draughtsman, as revealed in a series of letters responding to his persistent enquiries about the identification of *A Baron Numbering his Vassals.* (B23)[25]

Holliday and Whitworth Wallis died within months of each other in 1927, Fairfax Murray eight years earlier, in 1919. All three are linked by their advocacy of drawing as central to the Pre-Raphaelite vision, and by their key roles in establishing a remarkable public centre for the Pre-Raphaelites in Birmingham.

Notes

1 J. R. Holliday, born in 1840, was the son of William Holliday, a Lord Mayor and founder of a well-known drapery business in Birmingham. He attended St John's College, Cambridge, taking his articles as a solicitor in 1867, and joining the firm of Wragge and Co in his native city. He retired as a senior partner in the law firm in 1915, living at 101 Harborne Road, Edgbaston, before his death in 1927.

2 This group of drawings is accessioned (1903 P1-547) and includes William Morris's stained glass cartoon of *The Ascension* (1904 P534).

3 This group of drawings is accessioned (1906 P561-1076) and includes Walter Deverall's drawing of *James II Robbed by Fisherman while escaping from England* (1906 P794).

4 Stephen Wildman, 'Opportunity and Philanthropy: The Pre-Raphaelites as seen and collected in Birmingham', in *Visions of Love and Life*, Art Services International, 1995, pp 57–70.

5 *Loan Collection of Modern Pictures and the Permanent Collection of Paintings in Oil and Watercolours*, Birmingham Museum and Art Gallery, 1891.

6 J. T. Middlemore, 1896, as quoted in Stuart Davies, *By the Gains of Industry: Birmingham Museums and Art Gallery 1885–1985*, Birmingham Museums and Art Gallery, 1985.

7 David Elliott, 'Keeper of the Pre-Raphaelite Flame', in *Waking Dreams: The Art of the Pre-Raphaelites from the Delaware Art Museum*, Art Services International, 2004.

8 The author in conversation with David Elliott, 14th February 2004.

9 Charles Fairfax Murray diaries, Collection Frits Lugt, Institut Néerlandais, Paris, entry for 17th November 1887. I am most grateful to David Elliott for supplying me with this reference and the entry for note 10.

DRAWINGS

B1 Sketch of Horses at Dinan, France, 1836
Vo: faint figure sketches including crowned head
Pencil, 156 × 250 mm (6 × 9¾ in)
Insc vo: *Horses at Dinan France/ executed by Sir J E Millais at the age of 7/ J G Millais* (ink); on image: *Robert* (pencil)
Presented by J. G. Millais, 1926 (1926 P80)

B2 The Head of the Virgin after Correggio's 'Ecce Homo', 1837
Pencil, 290 × 238 mm (11¼ × 9¼ in)
Insc bl: *Presented to his Friend Mr Bessell/ 30ᵗʰ June 1837*, br: *John Everett Millais Aged 8 years 8ᵗʰ June/ 1837*, bc: *The Virgin Mary from the 'Ecce Homo' of Corregio* [sic, probably mother's hand]
Presented by National Art Collections Fund, 1916
1916 P17

Copy after the *Ecce Homo* in the National Gallery, almost certainly drawn from a reproductive engraving. Mr Bessell was the drawing master in Jersey from whom Millais received his first lessons in art. The Royal Academy of Arts has a slightly earlier drawing of the same Correggio head, dated to *16 March 1837* when Millais was *7 years 9 months*.

B3 Sketch of a Knight in Armour on Horseback: Marquis of Waterford, c.1839
Vo: another sketch of mounted figure insc: *Lord Cassilis*
With note from donor that the drawing was done by the ten-year-old Millais at the Tower of London
Pencil, 180 × 223 mm (7 × 8¾ in)
Insc on image r: *Marquis Waterford/ Marquis of*
Presented by J. G. Millais, 1926 (1926 P81)

B4 The Rejection of Cain's Sacrifice (Genesis IV), 1842
Sepia wash, 132 × 103 mm (5 × 4 in)
Insc bl: *JEM 42* (ink)
1906 P620

B5 Elgiva Seized by Order of Odo, Archbishop of Canterbury, 1843
Pen and black ink, 204 × 303 mm (8 × 12 in)
Insc br: *J E Millais/ 1843* (sepia ink), above paper edge tl: *AD 955*, tr: *Edwy* and b: *Elgiva seized by the orders of Odo, Archbishop of Canterbury* (pencil)
Purchased from Leger Galleries and presented by the John Feeney Trust, 1967 (1967 P47)

One of a series of drawings submitted for a competition organised by the Art Union of London on subjects from English Literature and history. Birmingham Museums has a small related oil sketch (1980 P127).

B6 Study for 'Sketches of Armour': Henry VIII, 1844
Pen and brown ink, 262 × 310 mm (10 ¼ × 12 in), with 12 armour items numbered
1906 P614

B7 Study for 'Sketches of Armour': Henry VIII, 1844
Pen and black ink, 262 × 331 mm (10¼ × 13 in), with ten armour items numbered
Insc tr: *Reign/ of/ Henry 8ᵗʰ* (ink)
1906 P615

B8 Study for 'Sketches of Armour': Elizabeth I, 1844
Pen and black ink with sepia inscription, 262 × 319 mm (10 ¼ × 12 ½ in), with 14 armour items numbered
Insc tr: *Elizabeth's Reign*
1906 P616

B9 Study for 'Sketches of Armour': James I, 1844
Pen and black ink, 267 × 330 mm (10½ × 13 in), with 12 armour items numbered
Insc tr: *James the 1st/ . . .* (ink)
Life, vol.1, p.33
1906 P617

B10 Study for 'Sketches of Armour': Charles I, 1844
Sepia ink, 266 × 317 mm (10½ × 12½ in), with 15 armour items numbered
Insc c: *J E Millais Charles 1ˢᵗ/ Reign* (ink)
1906 P618

B11 Andrea Ferara: The Armoury, 1844
Pen and sepia ink, 315 × 484 mm (12¼ × 19 in)
Insc br: *John E Millais* (ink), *Andrea Ferara* (on sword), *J E Millais/ Armour* on sheet of paper on wall
Purchased from Christie's, 19th July 1983
1983 P71

B12 Frontispiece: 'Sketches of Armour', 1845
Pen and black ink, 275 × 340 mm (10¾ × 13¼ in)
Insc br: *John Everett Millais Del./ 1845* (ink), tl: *Figures/ reduce to 8 inches/ wide* (wide)
Life, vol.1, p.31 repro
Formerly owned by artist's grandson, Edward Gray St Helier Millais (1918–2003), and purchased from Christie's 14th November 1967
1967 P48

A series of studies of armoury made at the Tower of London.

B13 The Gipsy, 1846
Watercolour heightened with bodycolour, 250 × 345 mm (9¾ × 13½ in)
Insc br: *J E Millais/ 1846* (ink)
British Watercolours, 91 repro.
1906 P660

B14 Lovers by a Rosebush, 1848
Pen and ink, 254 × 165 mm (10 × 6½ in)
Insc br: *J E Millais 1848* (ink), bl: *PRB* (monogram, ink), below image br: *John E Millais to his PRB* (as monogram)/ *brother Dante Gabriel Rossetti* (ink)
Wildman, 12
Purchased in 1920 (1920 P12)

B15 Study for 'Romeo and Juliet', 1848
Pen and black ink, 215 × 361 mm (8½ × 14 in)
Insc bl: *JEM/ 1848* (ink)
Fine Art Society, 1901, 29a; Hong Kong 1984, 32; Wildman, 11
Related to the smaller oil sketch of the same subject at Manchester City Art Gallery.
1906 P646

B16 Study for 'Isabella': Head of Isabella and One of her Brothers, and Caricature, 1848
Vo: study of old woman at table and sleeping dog
Pencil, 354 × 251 mm (14 × 9¾ in)
Wildman, p.102 repro
1906 P651

It has been suggested that the central sketch caricatures Rossetti's drawing of *A Parable of Love* also in the BMAG collection (1904 P491).

John Everett Millais: Catalogue of Drawings and Printed Illustrations at Birmingham Museums and Art Gallery

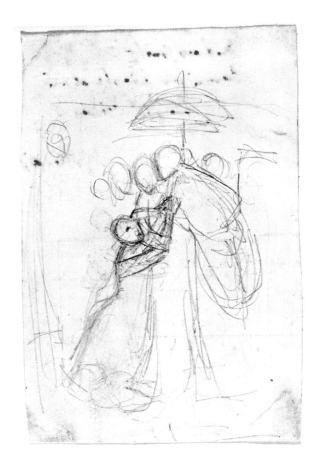

As identified by the capital B number sequence and accompanying accession number, the following collection, unless otherwise stated, was acquired by Birmingham Museum and Art Gallery (now Birmingham Museums and Art Gallery) from Charles Fairfax Murray and presented by subscribers in July 1906, or bequeathed by James R. Holliday in 1927. The works are all on paper, measured height before width in millimetres and inches, with the following abbreviations: vo – verso, insc – inscribed, c – centre, t – top, b – bottom.

The author has tried to distinguish between an initial sketch, where the artist is working something out, as opposed to a study, which is here regarded as a more worked up design, closer to the published version. Those works marked with an asterisk are in the accompanying exhibition.

Abbreviated References

British Watercolours	Stephen Wildman, *British Watercolours from Birmingham*, Birmingham Museums and Art Gallery, 1991.
Fine Art Society	*Exhibition of Pictures, Drawings and Studies for pictures made by the late Sir J. E. Millais Bart, P.R.A.*, London, Fine Art Society, 1901.
Hong Kong 1984	Richard Lockett, *Pre-Raphaelite Art from the Birmingham Museums and Art Gallery*, Hong Kong Museum of Art, 1984.
Life	John Guille Millais, *The Life and Letters of Sir John Everett Millais*, London, 1899 and 1900, two vols.
R.A. 1967	Mary Bennett, *Millais*, Liverpool, Walker Art Gallery, and London, Royal Academy of Arts, 1967.
R.A. 2003	Annette Wickham, *The Gifted Hand – Drawings by John Everett Millais from the Royal Academy's Collection*, London, Royal Academy of Arts, 2003.
Tate	*The Pre-Raphaelites*, London, Tate Gallery, 1984.
Warner	Malcolm Warner, *The Drawings of John Everett Millais*, Arts Council of Great Britain, Bolton Museum and Art Gallery and elsewhere, 1979.
Wildman	Stephen Wildman, *Visions of Love and Life: Pre-Raphaelite Art from the Birmingham Collection, England*, Alexandria, Virginia, Art Services International, 1995.
Wordsworth Trust, *Tennyson*, 1992	Robert Woof, *Tennyson (1809–1892): A Centenary Celebration*, Grasmere, The Wordsworth Trust, 1992.

Sketch for *The Prisoner's Wife: The Law Courts* (B78, p.59)

Appendix: Letter from J. R. Holliday to Charles Fairfax Murray, dated 23rd February 1903

Dear Mr Fairfax Murray

I now send you as promised cheque for £3000 – the receipt of which kindly acknowledge. As to the remaining £1000 I am asking the contributor – who is now in the south of France – to what extent and for how long he wishes to defer payment, and I will let you know when I hear from him. In the meantime you may take it from me that it will be all right. To prevent any misunderstanding let me say that I take it the price includes the drawings by DGR and EBJ in your lists, minus the 4 of DGR's included, and plus the additional things you have been good enough to include – big – the Madox Brown portrait, the Sandys portrait, the EBJ Earthly Paradise drawings, and the two sheets of studies (on brown paper I think). and the EBJ study for Danae. For these and any other additions you may generously make I feel very grateful – not only on personal grounds but in the interest of the Gallery.

The drawings already sent off will doubtless arrive tomorrow and I will ask Wallis to advise you of their delivery. As to the 'Rosso Vestita' by all means do as you think best.

I note what you say about the newspapers but I fear that will be difficult. Personally I dislike the atmosphere of publicity and advertisement, but in the present case publicity cannot be avoided, and when it is started it seems impossible to set a limit to it. The course of procedure invariably adopted involves in the first place a letter to the Lord Mayor offering the drawings to the Gallery. This letter is read at the next meeting of the City Council, and a formal Resolution is passed accepting the offer with the usual formal thanks to the donor. All this is reported in the evening local rags on the same day, and in the morning papers on the following day . . . Now these being the facts how would you like the matter to be dealt with? . . . I had all along assumed that when the drawings are in the Gallery your name would necessarily appear in connection with them and they could be known as the Fairfax Murray collection of drawings by DGR & EBJ or under some similar description to be approved by you. It does not seem right that your name should not appear in connection with the gift. How would it be if in writing to the Lord Mayor I said something to the effect that the drawings were a part of your collection which you had always intended should find a home in a public gallery and that at our request you had consented to let us have them for the purpose of securing them for our Gallery? . . . Wallis also suggests that if it is not troubling you too much you might write a short description of the drawings of which he will have copies made to give to the clamorous reporters . . . I ought to have said that there will be no possibility of any figures appearing – or if they do they will be an invention of the newspaper people – as the price will most certainly not be stated or in any way published.

Yours very truly J R Holliday

PS As to the two Rossetti drawings you mention I think it would be well to include these with the other things you will not part with now – but as to which you were good enough to say you would let us have a list with prices at which you would give us the option of acquiring them . . . As to the unmounted cartoons if you will send these as they are we will get them mounted and framed. These might be sent to me here. JRH

10 Letter from Charles Fairfax Murray to William Silas Spanton indicates that the former attended the Christie's sale of Burne-Jones and Millais paintings on 28th March 1886, 'Arrived at 6 in the morning after an abominable passage and called on the Stillmans and breakfasted with them before going to Christies [sic] . . . Rossetti's pen and ink drawing of "Found" the loss of which affected me so much was going begging at Agnews . . . for less than £75. I need not say that my cheque changed hands an hour later.' (Dulwich Picture Gallery 52, nd).

11 Drawings which it appears Fairfax Murray bought at the 1901 sale and which are now in the Birmingham collection include: *Pre-Raphaelite Drawing to illustrate a story by Rossetti for 'The Germ'* (27); *The Last Scene, Romeo and Juliet* (29a); *Study of a girl curtseying before a mirror* (59); *Seven Sketches for 'The Return of the Crusader'* (60); *Three Sketches for 'The Eve of St Agnes'* (83).

12 *Important Ancient and Modern Pictures The Property of Charles Fairfax Murray* . . . Christie's, 14th December 1917 with four paintings by Millais: *The Rescue* (47 × 30 in), lot 59; *Jephthah* (49½ × 63½ in), lot 60; *Flowing to the River* (55½ × 73½ in), lot 61; *Just Awake* (35 × 27 in), lot 62.

13 In correspondence with Malcolm Warner, 1st April 2004, where he also sites the illustrations for *Framley Parsonage* as appearing in the Thomas Plint sale of 7th March 1862. Birmingham Museums and Art Gallery has two watercolours, *A Wife* and *A Seamstress*, that are known to have been sold to the watercolourist Myles Birket Foster.

14 Introductory note by John Guille Millais, *Exhibition of Pictures, Drawings and Studies for Pictures made by the late Sir J. E. Millais Bart, P.R.A.*, Fine Art Society, London, April 1901.

15 John Guille Millais, *The Life and Letters of Sir John Everett Millais*, Methuen and Co, 1900, p.491, stating that a large volume of Millais drawings dating from 1848–54 and preserved by Effie Millais, as well as two highland sketchbooks from 1853, passed to the author (Millais's fourth son) and his brother Geoffrey (Millais's third son).

16 David Elliott, *Charles Fairfax Murray: The Unknown Pre-Raphaelite*, The Book Guild, Sussex, 2002, pp 129–30.

17 A. E. Whitley, *Catalogue of the Permanent Collection of Drawings*, Birmingham Museum and Art Gallery, 1939.

18 I am most grateful to David Elliott for locating the letter from J. R. Holliday to Charles Fairfax Murray, dated 23rd February 1903 (John Rylands Library, University of Manchester, 1261/357.358). See Appendix.

19 ibid

20 The J. H. Holliday bequest to Birmingham Libraries reveals Holliday's particular interest in fine printed books and the Kelmscott, Eragny, Vale and Dove presses. The library also received a significant group of fifteenth- and sixteenth-century Italian manuscripts.

21 Museum and School of Art Committee Report, 3rd May 1904.

22 Volume of designs by Burne-Jones for *Cupid and Psyche* has the following *ex libris* labels: *From the Library of CH: Fairfax Murray* and *Bequeathed by J. R. Holliday* (Birmingham Museums and Art Gallery 1927 P648). It is probable that Holliday acquired this volume in the period 1902–3 when negotiating with Fairfax Murray over the Birmingham sale of Pre-Raphaelite drawings.

23 Inventoried as 198 illustrations in 1927 (1927 P1696).

24 Birmingham Museums and Art Gallery Archive, Sydney Cockerell to S. C. Kaines Smith, 15th August 1927.

25 Nine letters to J. R. Holliday from F. G. Stephens, Holman-Hunt, William M. Rossetti and Fairfax Murray, the last from Fairfax Murray opening 'Your most provoking letter has just reached me. Dear old Stephens! (I really liked him) . . . Wm Rossetti is the most *painfully inaccurate* man I know . . .' (1906–11). BMAG.

B17 *Study for Isabella: Old Woman*, 1848
Vo: sketches of horse
Pencil, 339 × 250 mm (13¼ × 9¾ in)
Insc ll: monogram
1927 P902

B18 *Study for 'Isabella': Youth*, 1848
Pencil on cream paper laid onto card, 257 × 202 mm (10 × 8 in)
Insc br: *J E Millais 1848* (pencil)
1906 P653

B19 *Study for 'Isabella': Servant*, 1849
Lower head study may be for young girl at the bottom of the table on the right
Vo: sketch of sleeping greyhound
Pencil, 234 × 220 mm (9 × 8½ in)
Insc br: *J E Millais/ 1849* (ink)
1906 P652

B20 *Three Studies of a Sleeping Dog*, c.1849
Pencil, 146 × 225 mm (5¾ × 8¾ in)
Insc bl: *M* (ink) with four attempts at a monogram
1906 P603

B21 *Sketch of Three Men Gardening, Watched by Young Woman in Centre and Two Attendants*, 1849–50
Vo: related pencil drawings of gardening scene (cut)
Sepia pen and ink over pencil, 112 × 186 mm (4½ × 7¼ in)
1906 P631

B22 *Sketch of Three Men Gardening Watched by Figure and Two Attendants on Far Right*, 1849–50
Sepia pen and ink, 102 × 152 mm (4 × 6 in)
Life, vol.1, p.65 where described as unused design for *The Germ*
1906 P632

B23 *A Baron Numbering his Vassals*, 1850
Sketch for a picture never carried out, but realised as a watercolour (Tate)
Pen and black ink over pencil, 242 × 344 mm (9½ × 13½ in)
Life, vol.1, p.59; R.A. 1967, 269
1906 P619

Birmingham Museums and Art Gallery has nine letters to J. R. Holliday from F. G. Stephens, Holman-Hunt, W. M. Rossetti and Charles Fairfax Murray attempting to identify the subject of this drawing (1906–11). The Tate has a related drawing showing an expanded group of figures. As described by Malcolm Warner, the composition is based on an engraving by G. Paolo Lasinio Figlio after Giuseppe Rossi in *Pitture a Fresco del Camposanto di Pisa*, Pisa, 1833.

B24 *Sketch for 'St Agnes of Intercession'*, 1850 *
Scene of dying girl being painted by her lover; intended for illustrated etching in fifth unrealised volume of *The Germ*
Pencil, 109 × 175 mm (4¼ × 7 in)
Fine Art Society, 33; R.A. 1967, 249; Warner, 67
1906 P625.1

B25 *Etching 'St Agnes of Intercession'*, 1850 *
Etching, black ink; image: 108 × 178 mm (4¼ × 7 in), paper: 117 × 188 mm (4½ × 7¼ in)
Insc br margin: *WBS* monogram (William Bell Scott collector's stamp)
R.A. 1967, 116
1906 P625.2

The Fine Art Society catalogue entry in 1901 refers to Millais producing 'a few copies of the print' from the above drawing. To date, two other proofs

have been located, at the Victoria and Albert Museum and the Yale Center for British Art, New Haven.

B26 *Sketch of Evening Party*, 1850–51
Men singing to accompaniment, two men standing and one woman seated
Vo: caricature of man being pushed down hole
Sepia pen and ink, 171 × 229 mm (6¾ × 9 in)
1906 P601

B27 *Sketches for an Unrealised/ Unidentified Subject, Incorporating the Female Figure in 'Mariana' and Woman Folding Cloth*, c.1850
Pencil, 68 × 130 mm (2¾ × 5 in)
R.A. 1967, 258 where described as possibly related to *The Dove's First Flight*; Wordsworth Trust, *Tennyson*, 1992, 247
1906 P634

The image of a woman folding a piece of cloth appears in a compositional drawing of *Christ in the House of His Parents* in the Tate Collection. It has been recently suggested that this female figure may depict St Anne (Robert Upstone, *The Pre-Raphaelite Dream*, Tate Publishing, 2003).

B28 *Sketch for the Figure of Mariana in 'Mariana' and Woman Folding Cloth*, c.1850
Pencil, 129 × 120 mm (5 × 4¾ in)
R.A. 1967, 259
1906 P635

The oil painting of *Mariana* was begun in September 1850 (Tate).

B29 *Sketch for the Figure of Mariana in 'Mariana'*, c.1850
Vo: woman folding cloth (cut)
Pencil, 109 × 55 mm (4¼ × 2 in)
R.A. 1967, 260
1906 P636

B30 *Sketch of Unrealised/ Unidentified Subject of Woman Sewing*, c.1850
Vo: miscellaneous sketches of women sewing, girl folding cloth, caricatures and head study
Pencil, 164 × 108 mm (6½ × 4¼ in)
1906 P637

B31 *Sketch of Girl Folding Cloth*, c.1850
Vo: another sketch of woman folding cloth and seated figure in centre
Pencil with touches of black ink, 177 × 106 mm (7 × 4 in)
Life, vol.1, p.104 where described as sketch for *Mariana*
1906 P638

B32 *Sketch for Unrealised/ Unidentified Subject of Women Sewing*, c.1850
Possibly related to Rossetti's poem 'The Blessed Damozel', with figure of girl folding cloth and back stretching figure in *Mariana*
Vo: slight sketches of women sewing
Pencil, 123 × 206 mm (4¾ × 8 in)
Warner, 45
1906 P633

B33 *Sketch of Young Woman Being Consoled by Another Woman and a Man*, 1851
Vo: study of a female figure in evening dress, head turned away
Sepia pen and ink, 269 × 177 mm (10½ × 7 in)
Insc bc: *John Millais* and in another hand *(1851)*
R.A. 1967, 271; Hong Kong 1984, 34, repro
1906 P649

B34 Sketch for 'A Huguenot, on St Bartholomew's Day, Refusing to Shield himself from Danger by Wearing the Roman Catholic Badge (1560)', 1851–2
Pencil, 152 × 82 mm (6 × 3 in)
Hong Kong 1984, 33 repro
1906 P621

Arched frame is indicated around figures, who are reversed in the final painting in the Makins Collection, Washington.

B35 Sketch for 'A Huguenot': Woman Placing Chain and Cross Round her Lover's Neck, 1850–51
Pen and ink over pencil, 136 × 85 mm (5¼ × 3¼ in)
R.A. 1967, 276; Warner, 50
1906 P622

B36 Sketch for Wilkie Collins's 'Mr Wray's Cash-Box', 1851–2 *
Woman tying tie of lover
Pencil, 140 × 98 mm (5½ × 4 in)
Wordsworth Trust, Tennyson, 1992, 257 as a study for The Miller's Daughter
1906 P590

B37 Compositional Sketch for 'The Order of Release 1745', 1852
Sepia pen and ink over pencil, 120 × 82 mm (4¾ × 3 in)
Insc bl: The Ransom
1906 P624

The oil painting was completed in 1853 (Tate), with Effie Ruskin replacing Anne Ryan as model.

B38 Elizabeth Siddal: Study for 'Ophelia', 1852
Pencil, 232 × 307 mm (9 × 12 in)
Prov: Sir William Bowman, sold at Christie's 24th March 1893 (172); bought at this sale by Fairfax Murray for 10 guineas
Wildman, 22 illus
1906 P664

Other related drawings for Ophelia are in Plymouth Art Gallery and the Pierpont Morgan Library.

B39 Two Sketches for 'The Proscribed Royalist 1651': Puritan Girl Visiting Cavalier Lover, 1852
Vo: sketch for The Order of Release, partly cut
Pencil, 155 × 137 mm (6 × 5¼ in)
1906 P584

The related oil on canvas, first exhibited in the Royal Academy in 1853, is now in the Andrew Lloyd Webber Collection.

B40 Sketch for 'The Proscribed Royalist 1651': Puritan Girl Visiting Cavalier Lover, 1852
Pencil, 157 × 82 mm (6 × 3 in)
1906 P585

B41 Sketch of a Young Woman Curtseying in Front of a Mirror, Thought to be Effie Ruskin, 1852
Vo: sketch of a young woman
Pencil, 224 × 140 mm (8¾ × 5½ in)
Fine Art Society, 59
1927 P903

B42 Sketch of Effie Ruskin by a Window at Doune Castle, with Portraits of James Simpson (1811–1870) and Other Sketches, 1853
Vo: parodies of Raphael, Guercino and Teniers
Pen and brown ink, 188 × 234 mm (7¼ × 9 in)
Insc br: Sir J Simpson/ from memory (pencil)

Malcolm Warner and Mary Lutyens, Rainy Days at Brig O'Turk: The Highland Sketchbooks of John Everett Millais, Westerham, Kent, 1983
Millais Portraits, National Portrait Gallery, 1991, p.84
1906 P602

B43 Effie Ruskin Wearing a Dress Decorated with Natural Ornament, 1853
Inspired by Ruskin's ideas on the subject of ornament derived from natural forms
Pen and sepia ink, 185 × 233 mm (7¼ × 9 in)
Ruskin and the English Watercolour, Whitworth Art Gallery, University of Manchester, 1989, 102 illus
1906 P604

B44 Sketch of a Pinnate Leaf Breaking Bud (Three Leaves)
Pencil, 114 × 88 mm (4½ × 3½ in)
Hong Kong 1984, 37 illus
1906 P612

B45 Sketch of a Pinnate Leaf Breaking Bud (Five Leaves)
Pencil, 134 × 88 mm (5¼ × 3½ in)
1906 P611

B46 Sketch of Five Flower Heads
Pencil, 135 × 87 mm (5¼ × 3½ in)
1906 P609

B47 Sketch of Five Flower Heads (Side and Top)
Pencil, 134 × 87 mm (5¼ × 3½ in)
1906 P610

B48 Sketch of Reeds
Pencil, 128 × 84 mm (5 × 3¼ in)
1906 P608

B49 Sketch of Branch with Buds and Leaves
Pencil, 89 × 114 mm (3½ × 4½ in)
1908 P613

The above six sketches were exh: R.A. 1967, 318–23

B50 Study of Harebells, 1853
Vo: sketch of steep roofed house
Drawn at Glen Finlas, Perthshire, 1853
Pencil on laid writing paper, 177 × 113 mm (7 × 4½ in)
R.A. 1967, 326
Presented by J. G. Millais, 1926 (1926 P83)

B51 Sketch of Cottages, 1853
Vo: Sketches of Glen Finlas Perthshire 1853/ by Sir J E Millais PRA/ J G Millais (ink)
Pencil on laid writing paper, 114 × 177 mm (4½ × 7 in)
R.A. 1967, 325
Presented by J. G. Millais, 1926 (1926 P82)

B52 Sketch of Young Child and Head of a Woman
Pencil, 78 × 74 mm (3 × 3 in)
1927 P442

B53 Sketch of an Older Woman Reading with Child
Vo: further related sketches, partly cut
Pencil, 108 × 91 mm (4¼ × 3½ in)
1927 P905

B54 Sketch of Baby Sitting on Ground
Vo: back view of figure lying on ground
Pencil, 101 × 80 mm (4 × 3 in)
1927 P906

B55 Sketch of a Young Girl Sleeping on Chair
Pencil, 71 × 70 mm (2¾ × 2¾ in)
1927 P907

B56 Sketch of a Baby, Arms Raised
Vo: head and bird sketches, partly cut
Pencil, 85 × 77 mm (3¼ × 3 in)
1927 P908

B57 Sketch of a Baby Being Cradled
Vo: sketches of a cat
Pencil, 56 × 106 mm (2 × 4 in)
1927 P909

B58 Sketch of a Child Being Kissed
Pencil, 71 × 73 mm (2¾ × 3 in)
1927 P910

Eight pencil sketches of the heads of babies, originally on a single sheet

B59 Sleeping Child's Head
Vo: figure sketch; 82 × 72 mm (3 × 3 in); 1927 P911 (1)

B60 Sketch of a Child's Head Wearing Hat
Vo: smiling child's head; 57 × 42 mm (2¼ × 1½ in); 1927 P911 (2)

B61 Sketch of Child's Head Looking Down
52 × 50 mm (2 × 2 in); 1927 P911 (3)

B62 Sketch of a Child's Curly Head, Three Quarter View Looking Left
53 × 49 mm (2 × 2 in); 1927 P911 (4)

B63 Outline of a Child's Head, Turned to the Right
43 × 42 mm (1½ × 1½ in); 1927 P911 (5)

B64 Sketch of a Child's Head: Wearing a Headband
40 × 39 mm (1½ × 1½ in); 1927 P911 (6)

B65 Profile Sketch of a Child Turned to Left
40 × 40 mm (1½ × 1½ in); 1927 P 911 (7)

B66 Sketch of a Sleeping Young Girl's Head, Frontal
43 × 42 mm (1½ × 1½ in); 1927 P911 (8)

B67 Four Profile Head Sketches of Moustached Man
Vo: similar subject, reversed and numbered
Pencil on laid paper, 100 × 95 mm (4 × 3¾ in)
1906 P578

B68 Two Profile Sketches of Head, and Head and Shoulders Turned to Left
Vo: similar subject reversed
Pencil, 99 × 67 mm (4 × 2½ in)
1906 P579

B69 Sketch for a Gothic Window, Incorporating Angels Embracing, 1853
Vo: another sketch of embracing angels above a Gothic window with caricature of running soldier
Pencil, 231 × 175 mm (9 × 7 in)
1906 P605

A related design for a Gothic window is in the Andrew Lloyd Webber Collection (R.A. 2003, 19).

B70 Sketch of Ornament Design
Vo: sketch of reclining figure
Pencil, 215 × 134 mm (8½ × 5¼ in)
1906 P606

B71 Two Sketches of a Young Man Dressed for Shooting
Pencil, 178 × 112 mm (7 × 4½ in)
1906 P573

B72 Two Sketches of a Young Woman Holding a Book
Vo: another similar sketch
Pencil, 181 × 100 mm (7 × 4 in)
1906 P577

B73 Sketch of a Distraught Woman, Seated
Pencil on crested writing paper, 150 × 115 mm (6 × 4½ in)
1906 P582

B74 Studies of a Grasshopper: Body, Head and Leg, c.1853
Vo: sketch of a figure and head (sepia ink)
Watercolour and pencil, 184 × 224 mm (7 × 8¾ in)
R.A. 1967, 317
1906 P663

B75 Departure for the Country
Pen and ink over pencil, 179 × 111 mm (7 × 4¼ in)
Insc: *Subsequent/ spirited conduct on/ the part of the N.C.No 2 / Scene – Platform of a London Terminus . . .*
1906 P667

B76 Nothing Like Going Out of Town if You Want to Sleep
Pen and ink over pencil on blue paper, 223 × 182 mm (8¾ × 7 in)
1906 P666

B77 Sleep at Any Price
Pen and ink over pencil on blue paper, 180 × 112 mm (7 × 4½ in)
1906 P665

These three humorous drawings are similar in format to the sketches identified as: *An Artistic Stay in Winchelsea*, dated to 1854 and now part of the Andrew Lloyd Webber Collection (R.A. 2003, 63).

B78 Sketch of Kneeling Woman for 'The Prisoner's Wife': The Law Courts
Vo: related outline sketch of two figures with arms locked, cut at the top
Pencil, 162 × 109 mm (6¼ × 4¼ in)
Insc vo: *The Law Courts/ design for illustration/ by Sir J E Millais/ J G Millais* (ink)
Presented by J. G. Millais, 1926 (1926 P84)

B79 Sketch for 'The Prisoner's Wife': Wife Confronting Judge
Vo: sketch of back view of reclining woman
Pen and ink over pencil with touches of bodycolour, 113 × 112 mm (4½ × 4½ in)
Life, vol.1, p.231, and vol.2, p.490 where dated 1847; R.A. 1967, 208
1906 P626

B80 Sketch of a Woman in a Threatening Attitude, Arm Raised
Vo: similar subject
Pencil, 158 × 113 mm (6 × 4½ in)
1906 P600

A sheet of similar sketches of a woman attacking a man, dating from 1851 to 1852 and related to the early attempts to paint *The Ransom*, is in the Royal Academy of Arts Collection.

B81 The Rescue: Preliminary Cartoon, 1855
Pencil, charcoal, red and brown chalk, 999 × 718 mm (39 × 28 in)
Wildman, 32
Presented by Edward Nettlefold, 1901 (1901 P41)

B82 Sketches of a Girl Holding her Skirt, c.1856
Insc bl: *11 Montague St Portman Square* (pencil)
Pencil, 180 × 110 mm (7 × 4¼ in)
1906 P580

Substantially different to any of the girls in *Autumn Leaves*, with which it has been related.

B83 Sketch for Tennyson's 'St Agnes' Eve': Standing on the Convent Staircase and Looking Through Window, 1855–6 *
Pencil, 131 × 68 mm (5 × 2½ in)
1906 P596

Three sketches for *The Eve of St Agnes* were exhibited at the Fine Art Society in 1901 (83).

B84 Sketch for Tennyson's 'St Agnes' Eve': Stooping to Climb the Convent Staircase, 1855–6 *
Pencil, 115 × 90 mm (4½ × 3½ in)
1906 P662

B85 Sketch for Tennyson's 'St Agnes' Eve': Sitting on Convent Steps to Look Through Window, 1855–6 *
Pencil, 168 × 73 mm (6½ × 3 in)
Life, vol.1, p.305, repro where dated 1856; R.A. 1967, 348–50
Three sketches for an illustration to Tennyson's *St Agnes' Eve*, published by Edward Moxon, 1857.
1906 P595

B86 Sketch for Tennyson's 'The Sisters': Dead Figure of the Earl on Bed, with 'Sister' Combing his Hair, 1855–6
Pencil, 177 × 110 mm (7 × 4¼ in); not finally engraved for *Moxon*
Wordsworth Trust, *Tennyson*, 1992, 268
1906 P591

B87 Sketch for Tennyson's 'The Sisters': Outstretched Figure of the Dead Earl, Square Format, 1855–6
Pencil, 122 × 108 mm (4¾ × 4¼ in); not finally engraved for *Moxon*
Life, vol.1, p.304 illus
Wordsworth Trust, *Tennyson*, 1992, 267
1906 P592

B88 Sketch of Mother and Daughter for Tennyson's 'Locksley Hall', 1855–6
Vo: another sketch on reverse, which is close in the general positioning of the figures to the finalised wood-engraved illustration in *Moxon*, p.274
Pencil, 840 × 630 mm (32¾ × 24½ in)
1906 P627

B89 Two Sketches for Thomas Hood's 'The Reaper', 1855–8
Vo: reversed outline sketch for the same figure
Pencil on grey toned paper, 161 × 130 mm (6¼ × 5 in)
Passages from the Poems of Thomas Hood (etchings by the Junior Etching Club), E. Gambart, 1858
1906 P583

B90 Sketch for Tennyson's 'The Lord of Burleigh': The Death of Lord Burleigh – Nurse and Boy, 1855–6 *
The boy is close to the wood-engraved illustration
Vo: another sketch of the boy in ink
Pencil on blue laid paper, 181 × 113 mm (7 × 4½ in)
Moxon, 1857, p.353
1906 P567

B91 Sketches for Tennyson's 'Edward Gray': Emma Moreland Meeting Edward Gray, 1855–6 *
Pencil, 169 × 95 mm (6½ × 3¾ in)
Moxon, 1857, p.340; Warner, 71
1906 P630

B92 Sketch for Tennyson's 'The Day-Dream': The Revival – The King and Courtiers Awakening, 1855–6 *
Pencil, with additional Indian ink, 85 × 99 mm (3¼ × 4 in)
Moxon, 1857, p.323; Wordsworth Trust, *Tennyson*, 1992, 261
1906 P629

B93 Sketch for Tennyson's 'The Day-Dream': The Revival – The King and Courtiers Awakening, 1855–6 *
Pencil, 100 × 111 mm (4 × 4¼ in)
Moxon, p.323; Wordsworth Trust, *Tennyson*, 1992, 262 (more developed figures than 1906 P629)
1906 P594

B94 Two Sketches for Tennyson's 'Locksley Hall': Mother and Daughter Embracing, 1855–6
Pencil, 110 × 140 mm (4¼ × 5½ in), related illustration engraved in *Moxon*, 1857.
Vo insc: *Mrs Millais/ Annat Lodge* (ink) with rough sketch of poplar and clouds related to *Autumn Leaves* (Tate, 74)
1906 P593

Following their marriage, Effie and Millais lived at Annat Lodge, near Bowerswell (the Grays' family home) in Perthshire between August 1855 and May 1857. It proved a particularly productive time for Millais, when he worked on *Autumn Leaves* and *Apple Blossoms (Spring)*, as well as on his illustrations for *Moxon*.

B95 Sketch for Tennyson's 'Dora': The Quarrel Between Farmer Allen and his Son William, 1855–6
Vo: another sketch reversing figures
Pencil, 131 × 105 mm (5 × 4 in)
Insc t: *Dora* (pencil)
Wordsworth Trust, *Tennyson*, 1992, 252; *Moxon*, 1857, p.213
1906 P589

B96 Sketch for Tennyson's 'Dora': Figure of the Son in the Quarrel Between Farmer Allen and his Son William, 1855–6
Pencil, 120 × 76 mm (4¾ × 3 in)
Wordsworth Trust, *Tennyson*, 1992, 251
1906 P566

B97 Study for Tennyson's 'Dora': Mary, Child and Dora Comforting their Father/Grandfather, c.1855–6 *
Watercolour over pencil (arched design), 135 × 153 mm (5¼ × 6 in)
Insc bl with monogram, and bc: *Dora* (wash)
Published as engraved illustration: *Moxon*, 1857, p.219; Wildman, p.41;
Wordsworth Trust, *Tennyson*, 1992, 255
1906 P647

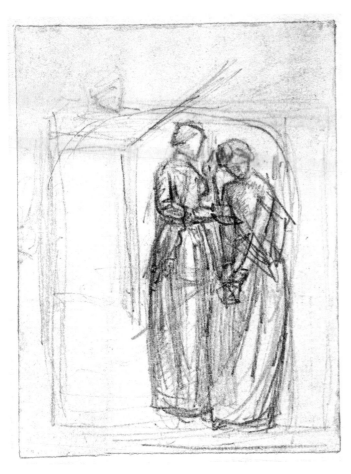

Sketch for Tennyson's *Locksley Hall*, 1855–6 (B88, p.60)

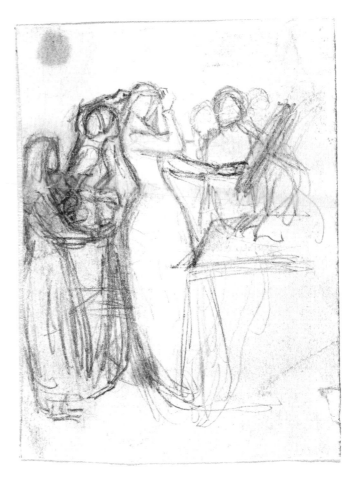

Sketch for Tennyson's *The Talking Oak: The Tiring of the Bride*, 1855–6 (B102, p.61)

B98 Sketch for Tennyson's 'Dora': Woman Bending Over Child, Two Other Children on Right, and Seated Man on Left, c.1856
Vo: two Arab figures
Pencil, 131 × 175 mm (5 × 7 in)
Wordsworth Trust, *Tennyson*, 1992, 253
1906 P581

B99 Study for Husband and Wife in Tennyson's 'The Miller's Daughter': 'Arise and Let Us Wander Forth', 1855–6
Vo: *Arise & let us wander/ forth/ Tennyson* (pencil)
Pencil, 174 × 121 mm (6¾ × 4¾ in), for Tennyson's *Moxon*, but not engraved
Wordsworth Trust, *Tennyson*, 1992, 259
1906 P588

B100 Study for Husband and Wife in Tennyson's 'The Miller's Daughter': 'Arise and Let Us Wander Forth', 1855–6
Figures now shown with window
Pencil, 125 × 111 mm (5 × 4¼ in), for Tennyson's *Moxon* but not engraved
Insc b: *Arise and let us wander forth/ &c &c &c* (pencil)
1906 P587

B101 Sketch of Kissing Couple
Vo: another sketch of the same subject with caricatured head
Pencil, 94 × 80 mm (3¾ × 3 in)
Moxon, 1857, p.86; Wordsworth Trust, *Tennyson*, 1992, 258
1906 P628

This sketch has been catalogued as related to Tennyson's *The Miller's Daughter* but may be a preliminary idea for *Mr Wray's Cash-Box* (see no.3 in the list of Exhibits).

B102 Sketch for Tennyson's 'The Talking Oak': The Tiring of the Bride, 1855–6
Pencil, 108 × 79 mm (4¼ × 3 in)
Moxon, 1857, p.255
1906 P565

B103 Sketch for Tennyson's 'The Talking Oak': The Shielding from Cupid, 1855–6
Pencil, 99 × 106 mm (4 × 4 in)
Life, vol.1, p.330 where dated 1858
1906 P586

B104 Sketches for 'The Return of the Crusader': Crusader and Wife, 1855–6
Vo: another sketch of figures reversed
Pencil, 169 × 112 mm (6½ × 4½ in) (variable)
1906 P644

The seven sketches for the unrealised *The Return of the Crusader* in the Birmingham Museums and Art Gallery Collection appear to have been purchased by Fairfax Murray from the Fine Art Society in 1901 (60).

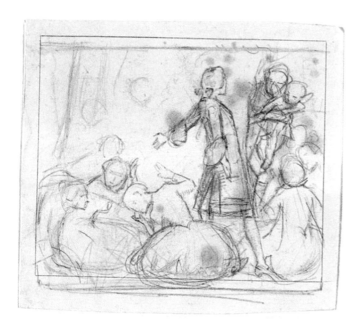

B105 *Sketches for 'The Return of the Crusader': Crusader and Wife with Crowd*, 1855–6
Vo: wife stretching out arms to hold husband
Pencil, 184 × 112 mm (7 × 4½ in)
1906 P645

B106 *Sketch for 'The Return of the Crusader': Wife in Bed*, 1855–6
Sepia pen and ink, 159 × 114 mm (6¼ × 4½ in)
1906 P642

B107 *Sketch for 'The Return of the Crusader': Wife in Bed*, 1855–6
Vo: similar sketch
Pencil, 169 × 109 mm (6½ × 4¼ in)
1906 P643

B108 *Sketches for 'The Return of the Crusader': Bedridden with Compositional Sketch*, 1855–6
Vo: scribbling and three slight head sketches
Pencil with pen and ink, 130 × 213 mm (5 × 8¼ in)
Insc tr: *The Crusader's Return*, br: *Home from the Crusades/ What is man that thou should'st/ care so much for him* (pencil)
1906 P641

B109 *Sketch for 'The Return of the Crusader': Crusader Facing Right and Shaking Hands*, 1855–6
Pencil, 110 × 130 mm (4¼ × 5 in)
1906 P639

B110 *Sketch for 'The Return of the Crusader': Crusader Facing Left and Shaking Hands*, 1855–6
Pencil, 110 × 90 mm (4¼ × 3½ in)
1906 P640

B111 *Two sketches for 'The Escape of a Heretic': The Bound Monk with Arms Tied Behind Back*, c.1857
Vo: rough outline sketch for same figure
Pencil, 135 × 105 mm (5¼ × 4 in)
1906 P564

B112 *Two sketches for 'The Escape of a Heretic': The Bound Monk Twisting to Face the Front*, c.1857
Vo: rough outline sketch for the same figure
Pencil, 163 × 102 mm (6½ × 4 in)
1906 P563

B113 *Sketch for 'The Escape of a Heretic': The Girl and her Lover*, c.1857
Vo: rough outline sketches of the same two figures
Pencil, 273 × 180 mm (10½ × 7 in)
1906 P562

B114 *Sketch for 'The Escape of a Heretic': The Girl and her Lover*, c.1857
Vo: four sketches of the same two figures, including arched frame around composition with inscription: *Mr Buchanan*
Pencil, 223 × 135 mm (9 × 5¼ in)
1906 P561

B115 *Finished Study of 'The Vale of Rest'*, 1858
Pen and brush ink, touched with white, 175 × 287 mm (7 × 11 in)
Insc br: monogram
The related painting is in the Tate collection.
1906 P650

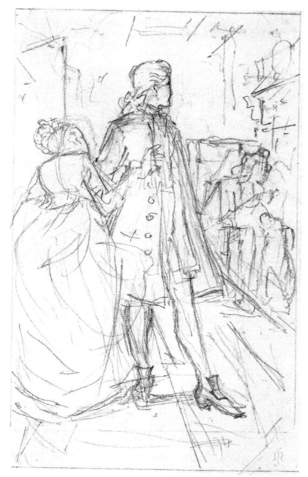

TOP Sketch for Tennyson's *The Talking Oak: The Shielding from Cupid*, 1855–6 (B103, p.61)

Sketch of a Fashionable Eighteenth-Century Man, and Woman (B138, p.64)

B116 *Sketch for 'The Plague of Elliant': A Cart Carrying the Dead,* 1859 *
Pencil, 111 × 170 mm (4¼ × 6½ in)
Published as engraved illustration: *Once a Week*, 15th October 1859, p.316;
R.A. 1967, 373
1906 P569

B117 *Three Sketches for George Meredith's 'The Crown of Love': Lover Carrying the Princess up the Hill,* 1859 *
Pencil on blue paper, 130 × 208 mm (5 × 8 in)
Vo: *PS/ The other block for 'Once a Week' is in a forward state*
Published as engraved illustration: *Once a Week*, 31st December 1859, p.10;
Life, vol.2, p.418
1906 P571

B118 *Sketch for Tennyson's 'The Grandmother's Apology',* 1859 *
Pencil, 103 × 127 mm (4 × 5 in)
Published as engraved illustration: *Once a Week*, 16th July 1859, p.241
1906 P574

B119 *Sketch for 'The Grandmother's Apology': Girl Seated on Floor,* 1859 *
Pencil, 155 × 103 mm (6 × 4 in)
Once a Week, 16th July 1859, p.241
1906 P575

B120 *Sketches for Christina Rossetti's 'Maude Clare': Figures and Two Head Studies of Maude Clare,* 1859 *
Vo: similar but reversed sketch of figure and head
Pencil, 167 × 123 mm (6½ × 4¾ in)
Once a Week, 5th November 1859, p.382
1906 P576

B121 *Sketch for Christina Rossetti's 'Maude Clare': Maude Clare,* 1859
Another sketch of same figure
Pencil, 187 × 75 mm (7¼ × 3 in) (variable)
1906 P661

B122 *A Wife: 'Face in Both Hands She Knelt on the Carpet',* 1860–63 *
Watercolour with touches of bodycolour, image: 96 × 121 mm (3¾ × 4¾ in),
paper: 102 × 127 mm (4 × 5 in)
Insc br: monogram
Prov: Birket Foster, sold Christie's 28th April 1894 (32); bought by dealers
Gooden and Fox for 10 ½ guineas; owned by Fairfax Murray by 1899.
Published as engraved illustration to anonymous poem: *Once a Week*, 7th
January 1860, p.32; Warner, 75
1906 P656

This watercolour is thought to have been produced after the black and white
illustration of 1860.

B123 *Four Sketches of Female Figures*
Vo: Four studies of irises. Central study of a young girl facing viewer shows
some similarity with central figure in *Apple Blossoms*, 1859
Pencil, 220 × 191 mm (8½ × 7½ in)
1906 P607

B124 *The Seamstress from Stewart Harrison's 'The Iceberg',* 1860 *
Watercolour with scratching, image: 101 × 128 mm (4 × 5 in), sheet: 112 ×
138 mm (4½ × 5½ in) (irreg)
Insc br: monogram
Prov: Birket Foster; Christie's sale 28th April 1894 (33); purchased by the
dealers Gooden and Fox for 21 guineas; owned by Fairfax Murray by 1905
when exhibited at Whitechapel Art Gallery

Published as engraved illustration: *Once a Week*, 6th October 1860;
Wildman, 53
1906 P655

B125 *Sketch for George Meredith's 'The Head of Bran': Seven Princes Carrying the Head of Bran,* 1860
Vo: another sketch of same scene, numbered
Pencil, 100 × 160 mm (4 × 6¼ in)
Once a Week, 4th February 1860, p.132; R.A. 1967, 375
1906 P570

B126 *Sketch of Mother Feeding Baby,* c.1860
Pencil, 184 × 107 mm (7 × 4 in)
Life, vol.1, p.317 where dated c.1860
1906 P598

B127 *Sketch of a Seated Woman Holding Lamp,* c.1860
Pencil, 175 × 122 mm (7 × 4¾ in)
1906 P 597

B128 *Sketch of a Mother and Child (Breastfeeding),* c.1860
Vo: another sketch of a similar subject, mother scrutinising baby
Pencil, 172 × 112 mm (6¾ × 4½ in)
1906 P599

B129 *Study of Girl's Head, Thought to Be Miss Gregson,* c.1860
Pencil, laid onto card, 212 × 178 mm (8¼ × 7 in)
With attached note: *The property of George P Boyce who bought it/ at Christie &
Manson's on Janry 15th 1866/ for 24s/- (written by G P Boyce).*
Hong Kong 1984, 38 illus
1906 P654

B130 *Sketch for 'The Black Brunswicker',* 1859–60
Vo: three sketches of lovers taking their leave, and female figure related to
The Eve of St Agnes, 1863
Pencil, 147 × 113 mm (5¾ × 4½ in)
1906 P623

This is a sketch for the oil painting in Lady Lever Art Gallery, Port Sunlight.

B131 *'Mark' she said 'The men are here' from Anthony Trollope's 'Framley Parsonage',* 1861 *
Pen and brown ink and watercolour, 249 × 176 mm (9¾ × 7 in)
Published: *Cornhill Magazine*, March 1861
Insc br: monogram and *1861*
1906 P648

B132 *Farmer Chell's Kitchen from Harriet Martineau's 'The Anglers of the Dove',* 1862 or later *
Watercolour with bodycolour on cream paper, laid onto card; image: 119 ×
134 mm (4½ × 5¼ in), overall size 131 × 145 mm (5 × 5¾ in)
Insc bl: with monogram
Published as engraved illustration: *Once a Week*, 19th July 1862, p.85
1931 P42

B133 *'Sorting the Prey' from Harriet Martineau's 'The Anglers of the Dove',* 1862 or later *
Watercolour with scratching out, image: 144 × 116 mm (5¾ × 4½ in), paper:
164 × 134 mm (6½ × 5¼ in)
Published as engraved illustration: *Once a Week*, 26th July 1862, p.113
Purchased through the Leadbeater Bequest Fund, 1926 (1926 P1)

B134 'Sister Anna's Probation' by Harriet Martineau, 1862 or later *
Watercolour with touches of bodycolour on cream paper on card, image: 120 × 130 mm (4¾ × 5 in), card: 140 × 153 mm (5½ × 6 in)
Insc br: monogram
Published as engraved illustration: *Once a Week*, April 1862, p.42
1927 P901

B135 Study for Thackeray's 'Barry Lyndon': Barry Lyndon's First Love, 1878–9 *
Barry Lyndon binding up the arm of his cousin Nora
Pen and ink with white bodycolour, 233 × 170 mm (9 × 6½ in)
Insc br: *1879* and monogram (ink)
The Works of William Makepeace Thackeray, Smith, Elder, 1879
1906 P657

B136 Study for Thackeray's 'Barry Lyndon': The Intercepted Letters, 1878–9 *
Pen and black ink with white bodycolour, laid onto board, 198 × 158 mm (7¾ × 6 in)

Insc bl: *1879* with monogram
The Works of William Makepeace Thackeray, Smith, Elder, 1879
1906 P658

B137 Study for Thackeray's 'Barry Lyndon': The Last Days of Barry Lyndon, 1878–9 *
Vo: Barry Lyndon kneeling to kiss woman's hand (pencil)
Pen and black ink with touch of bodycolour, 201 × 155 mm (8 × 6 in)
The Works of William Makepeace Thackeray, Smith, Elder, 1879; *Arts Council*, 87
1906 P659

B138 Sketch of a Fashionable Eighteenth-Century Man, and Woman
Pencil, 198 × 124 mm (7¾ × 5 in)
Insc br: monogram (pencil)
1927 P904

This sketch may possibly relate to the drawings for *Barry Lyndon*.

PRINTED ILLUSTRATIONS

Metal Electroplated Facsimiles from Engraved Wood Blocks
This collection consists of printed illustrations cut out of periodicals. It is thought to have come from the bequest of J. R. Holliday dating from 1927, but only accessioned in 1978. The titles for the series of designs published in *Once a Week* do not appear on the illustrations themselves but are suggestions to convey the sense of what is being depicted. Measurements are of image and small paper surround.

ONCE A WEEK

B139 Master Olaf, a German poem by L. B.
Engraved by Joseph Swain, 105 × 133 mm (4 × 5 in)
Once a Week, 14th July 1860, p.63
1978 P620 (8)

B140 Violet, a poem by Arthur Munby
Engraved by Joseph Swain, 106 × 99 mm (4 × 4 in)
Once a Week, 28th July 1860, p.140
1978 P626 (8)

B141 B. S. Montgomery's 'Dark Gordon's Bride'
Engraved by Joseph Swain, 117 × 130 mm (4½ × 5 in)
Once a Week, 25th August 1860, p.238
1978 P626 (5)

B142 The Meeting, illustration to poem by G. M.
Engraved by Joseph Swain, 95 × 89 mm (3¾ × 3½ in)
Once a Week, 1st September 1860, p.276
1978 P626 (7)

Stewart Harrison's *The Iceberg*. Engraved by Joseph Swain

B143 The Seamstress
105 × 130 mm (4 × 5 in)
Once a Week, 6th October 1860, p.655
1978 P626 (6)

B144 Esther's Death
104 × 130 mm (4 × 5 in)
Once a Week, 13th October 1860, p.435
1978 P626 (13)

B145 A Head of Hair for Sale by an anonymous author
Engraved by Joseph Swain, 120 × 99 mm (4¾ × 4 in)
Once a Week, 3rd November 1860, p.519
1978 P621 (5)

B146 Mary C. F. Münster's 'Iphis and Anaxarete'
Engraved by Joseph Swain, 78 × 131 mm (3 × 5 in)
Once a Week, 19th January 1861, p.98
1978 P626 (9)

B147 The Hunt for the Hammer, a poem by G. W. D.
Engraved by Joseph Swain, 80 × 126 mm (3 × 5 in)
Once a Week, 26th January 1861, p.126
1978 P626 (12)

B148 Tannhäuser *
Engraved by Joseph Swain, 117 × 98 mm (4½ × 4 in)
Once a Week, 17th August 1861, p.211 to a poem signed *LDG*
1978 P619 (10)

B149 Swing Song, an anonymous poem
Engraved by Joseph Swain, 132 × 85 mm (5 × 3¼ in)
Once a Week, 12th October 1861, p.434
1978 P619 (11)

B150 Schwerting of Saxony
Engraved by Joseph Swain, 97 × 135 mm (3¾ × 5¼ in)
Once a Week, 4th January 1862, p.43 for poem signed *AD*
1978 P619 (1)

B151 The Battle of the Thirty: A Breton Ballad
Engraved by Joseph Swain, 121 × 134 mm (4¾ × 5¼ in)
Once a Week, 1st February 1862, p.155
1978 P619 (12)

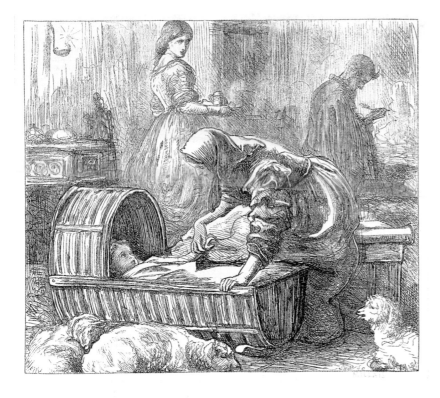

Wood-engraved illustration, *Farmer Chell's Kitchen*, 1862 (B163, p.66)

Wood-engraved illustration, *Kept in the Dark*, 1882 (B222, p.68)

B152 The Fair Jacobite
Engraved by Joseph Swain, 124 × 103 mm (5 × 4 in)
Once a Week, 22nd February 1862, p.239
1978 P620 (14)

Harriet Martineau's *Sister Anna's Probation*. Engraved by Joseph Swain

B153 Anna Confides in her Mother
122 × 134 mm (4¾ × 5¼ in)
Once a Week, 15th March 1862, p.142
1978 P621 (6)

B154 Anna Receives Instruction
135 × 109 mm (5¼ × 4¼ in)
Once a Week, 22nd March 1862, p.337
1978 P621 (4)

B155 Anna Meets her Secret Lover, Henry
135 × 107 mm (5¼ × 4 in)
Once a Week, 29th March 1862, p.365
1978 P621 (2)

B156 Anna in the Convent Garden with Sister Perpetua
134 × 106 mm (5¼ × 4 in)
Once a Week, 5th April 1862, p.393
1978 P621 (3)

B157 Anna and Henry Are United *
121 × 135 mm (4¾ × 5¼ in)
Once a Week, 12th April 1862, p.421
1978 P621 (1)

B158 The Crusader's Wife, a Breton poem translated by Tom Taylor
Engraved by Joseph Swain, 119 × 101 mm (4½ × 4 in)
Once a Week, 1863, 10th May 1862, p.546
1978 P619 (6)

B159 The Chase of the Siren, a poem by Walter Thornbury
Engraved by Joseph Swain, 123 × 103 mm (4¾ × 4 in)
Once a Week, 31st May 1862, p.630
1978 P619 (5)

B160 The Drowning of Kaer-is: 'I'll Win the Key from my Father's Side'
Engraved by Joseph Swain, 119 × 133 mm (4½ × 5 in)
Once a Week, 14th June 1862, p.687
1978 P619 (13)

B161 Margaret Wilson (Scottish Martyr)
Engraved by Joseph Swain, 160 × 134 mm (6¼ × 5¼ in)
Once a Week, 5th July 1862, p.42
1978 P620 (2)

B162 Sir Gawain and Maid Avoraine
Engraved by Joseph Swain, 106 × 134 mm (4 × 5¼ in)
Once a Week, 19th July 1862, p.98
1978 P619 (2)

Harriet Martineau's *The Anglers of the Dove*. Engraved by Joseph Swain

B163 *Farmer Chell's Kitchen*
121 × 135 mm (4¾ × 5¼ in)
Once a Week, 19th July 1862, p.85
1978 P625 (2)

B164 *Stansbury and Felton Sort the Prey* *
134 × 106 mm (5¼ × 4 in)
Once a Week, 26th July 1862, p.113
1978 P625 (6)

B165 *A Glimpse of Mary Queen of Scots*
120 × 134 mm (4¾ × 5¼ in)
Once a Week, 2nd August 1862, p.141
1978 P625 (5)

B166 *Polly in Reverie*
109 × 134 mm (4¼ × 5¼ in)
Once a Week, 9th August 1862, p.169
1978 P625 (1)

B167 *Polly Sees the Bonfires*
Once a Week, 16th August 1862, p.197
1978 P625 (3)

B168 *The Mite of Dorcas*
Engraved by Joseph Swain, 135 × 84 mm (5¼ × 3¼ in)
Once a Week, 16th August 1862, p.224
1978 P619 (9)

B169 *The Spirit of the Vanished World*, a poem by **Mrs Acton Tindal**
Engraved by Joseph Swain, 116 × 133 mm (4½ × 5 in)
Once a Week, 8th November 1862, p.546
1978 P620 (10)

B170 *The Parting of Ulysses*
Engraved by Joseph Swain, 115 × 95 mm (4½ × 3¾ in)
Once a Week, 6th December 1862, p.658
1978 P619 (3)

B171 *King Arthur* from **William Buchanan's** poem *Sir Tristem*
Engraved by Joseph Swain, 85 × 134 mm (3¼ × 5¼ in)
Once a Week, 22nd March 1862
1978 P619 (4)

B172 *Limerick Bells: The Monk*, a poem by **Horace Moule**
Engraved by Joseph Swain, 135 × 108 mm (5¼ × 4¼ in)
Once a Week, 20th December 1862, p.710
1978 P619 (7)

B173 *Endymion on Latmos*
Engraved by Joseph Swain, 134 × 108 mm (5¼ × 4¼ in)
Once a Week, 3rd January 1863, p.42
1978 P619 (8)

Harriet Martineau's *The Hampdens*, an historiette. Engraved by Joseph Swain

B174 *Now You Have Seen the Sea*
109 × 135 mm (4¼ × 5¼ in)
Once a Week, 14th February 1863, p.211
1978 P627 (9)

B175 *Gathering Flowers*
120 × 134 mm (4¾ × 5¼ in)
Once a Week, 21st February 1863, p.239
1978 P625 (4)

B176 *The Hampdens Approach their Home*
119 × 132 mm (4½ × 5 in)
Once a Week, 28th February 1863, p.267
1978 P627 (6)

B177 *Sir Oliver, Helen and Henrietta*
120 × 133 mm (4¾ × 5 in)
Once a Week, 7th March 1863, p.281
1978 P627 (5)

B178 *Henrietta Pondering*
118 × 134 mm (4½ × 5¼ in)
Once a Week, 14th March 1863, p.309
1978 P627 (8)

B179 *We Have Both Been Weak and Passionate*
121 × 132 mm (4¾ × 5 in)
Once a Week, 21st March 1863, p.337
1978 P627 (7)

B180 *Henrietta in her Room*
136 × 120 mm (5¼ × 4¾ in)
Once a Week, 28th March 1863, p.365
1978 P627 (1)

B181 *Harry and Henrietta Ride Away*
100 × 120 mm (4 × 4¾ in)
Once a Week, 4th April 1863, p.393
1978 P627 (2)

B182 *John Hampden Speaks to his Daughter*
114 × 134 mm (4½ × 5¼ in)
Once a Week, 11th April 1863
1978 P627 (4)

B183 *Henrietta Spends her Remaining Days Alone*
107 × 132 mm (4¼ × 5 in)
Once a Week, 18th April 1863, p.449
1978 P627 (3)

B184 *Hacho, the Dane; or the Bishop's Ransom: a poem by* **C. H. W.** from a legend of Llandaff
134 × 120 mm (5¼ × 4¾ in)
Once a Week, 24th October 1863, p.504
1978 P620 (7)

Harriet Martineau's *Son Christopher*, an historiette. Engraved by Joseph Swain

B185 *Christopher Confides in his Father*
120 × 102 mm (4¾ × 4 in)
Once a Week, 24th October 1863, p.491
1978 P624 (6)

B186 *The Constables Break Into the House*
109 × 135 mm (4¼ × 5¼ in)
Once a Week, 31st October 1863, p.519
1978 P624 (1)

B187 Squire Battiscombe meets Monmouth
122 × 133 mm (4¾ × 5¼ in)
Once a Week, 7th November 1863, p.547
1978 P624 (5)

B188 Watching their Idol as he Galloped Away
106 × 130 mm (4 × 5 in)
Once A Week, 14th November 1863, p.575
1978 P624 (7)

B189 The Duke Actually Remembered the Child Again
121 × 135 mm (4¾ × 5¼ in)
Once a Week, 21st November 1863, p.603
1978 P624 (2)

B190 The Service at Home
133 × 106 mm (5¼ × 4 in)
Once a Week, 5th December 1863, p.659
1978 P624 (4)

B191 The Battiscombes Leave Home
120 × 133 mm (4¾ × 5¼ in)
Once a Week, 12th December 1863, p.687
1978 P624 (3)

CORNHILL MAGAZINE

Anthony Trollope's *Framley Parsonage*. Engraved by Dalziel Brothers

B192 Lord Lufton and Lucy Robarts: Frontispiece *
178 × 114 mm (7 × 4½ in)
Cornhill Magazine, April 1860, p.449
1978 P618 (1)

B193 Was it not a Lie? *
182 × 127 mm (7 × 5 in)
Cornhill Magazine, June 1860, p.691
1978 P618 (2)

B194 The Crawley Family
180 × 126 mm (7 × 5 in)
Cornhill Magazine, August 1860, p.129
1978 P618 (4)

B195 Lady Lufton and the Duke of Omnium
177 × 118 mm (7 × 4½ in)
Cornhill Magazine, October 1860, p.472
1978 P618 (3)

B196 Owen Meredith's 'Last Words'
153 × 116 mm (6 × 4½ in)
Cornhill Magazine, November 1860, p.513
1978 P620 (3)

B197 Irené *
Engraved by Swain, 174 × 115 mm (6¾ × 4½ in)
Cornhill Magazine, April 1862, p.478 to a poem signed *RM*
1978 P620 (11)

B198 The Bishop and the Knight
175 × 108 mm (7 × 4¼ in)
Cornhill Magazine, July 1862, p.100 to a poem signed *M*
1978 P620 (12)

Anthony Trollope's *The Small House at Allington*. Engraved by Dalziel Brothers

B199 Please, Ma'am, can we have the peas to shell? *
174 × 113 mm (6¾ × 4½ in)
Cornhill Magazine, September 1862, p.364
1978 P623 (3)

B200 And You Love Me, Said She
166 × 112 mm (6½ × 4½ in)
Cornhill Magazine, October 1862, p.553
1978 P623 (2)

B201 It's All the Fault of the Naughty Birds
165 × 108 mm (6½ × 4¼ in)
Cornhill Magazine, November 1862, p.663
1978 P626 (2)

B202 'Mr Cradell, Your Hand', said Lupex
165 × 110 mm (6½ × 4¼ in)
Cornhill Magazine, December 1862, p.780
1978 P623 (1)

B203 'Dear Child! He Comes – Nay, Blush Not So' from R. Monckton Milnes's Unspoken Dialogue
176 × 112 mm (7 × 4½ in)
Cornhill Magazine, February 1860
1978 P626 (1)

GOOD WORDS

B204 King Olaf
Engraved by Dalziel Brothers, 95 × 134 mm (3¾ × 5¼ in)
Good Words, 1862, p.25
1978 P620 (6)

Dinah Mulock's (Mrs Craik) *Mistress and Maid*, a household story with 12 illustrations. Engraved by Dalziel Brothers

B205 In the Churchyard
157 × 119 mm (6 × 4½ in)
Good Words, 1862 (frontispiece)
1978 P626 (14)

B206 'What Did You Want to Write?' (Hilary and Elizabeth)
161 × 123 mm (6¼ × 4¾ in)
Good Words, 1862, p.97
1978 P622 (3)

B207 Street Scene with Lovers by Lamplight
158 × 122 mm (6¼ × 4¾ in)
Good Words, 1862, p.161
1978 P622 (6)

B208 Waiting in the Railway Station
161 × 122 mm (6¼ × 4¾ in)
Good Words, 1862, p.225
1978 P622 (7)

B209 A Visitor Announced
161 × 123 mm (6¼ × 4¾ in)
Good Words, 1862, p.289
1978 P622 (4)

B210 In the Boot Shop
158 × 120 mm (6¼ × 4¾ in)
Good Words, 1862, p.353
1978 P622 (1)

B211 The Arrest of Ascott
158 × 119 mm (6¼ × 4½ in)
Good Words, 1862, p.417
1978 P622 (2)

B212 Only a Servant
157 × 118 mm (6 × 4½ in)
Good Words, 1862, p.481
1978 P626 (2)

B213 Hilary's Resolution
159 × 120 mm (6¼ × 4¾ in)
Good Words, 1862, p.545
1978 P622 (8)

B214 The Wedding Morning
158 × 120 mm (6¼ × 4¾ in)
Good Words, 1862, p.609
1978 P620 (13)

B215 Mrs Ascott's Death-Bed
159 × 122 mm (6¼ × 4¾ in)
Good Words, 1862, p.673
1978 P622 (5)

B216 Norman Macleod's 'Highland Flora'
113 × 135 mm (4½ × 5¼ in)
Good Words, 1862, p.393
1978 P620 (1)

B217 O the Lark is Singing in the Sky, a poem by R. B. R. *
Engraved by Joseph Swain, 147 × 112 mm (5¾ × 4½ in)
Good Words, 1864, p.64
1978 P620 (9)

B218 A Scene for a Study, poem by Jean Ingelow
Engraved by Joseph Swain, 142 × 111 mm (5½ × 4¼ in)
Good Words, 1864, p.161
1978 P626 (10)

B219 Polly
Engraved by Joseph Swain, 165 × 120 mm (6½ × 4¾ in)
Good Words, 1864, p.248
1978 P620 (5)

B220 The Bridal of Dandelot, poem by Dora Greenwell
'The word She spoke so soft and low/ a Bird hath ta'en to Dandelot'
Engraved by Joseph Swain, 164 × 118 mm (6½ × 4½ in)
Good Words, 1864, p.304
1978 P626 (11)

B221 Prince Philibert
Engraved by Joseph Swain, 160 × 113 mm (6¼ × 4½ in)
Good Words, 1864, p.481
1978 P620 (4)

B222 When the Letter Was Completed She Found It to Be One Which She Could Not Send from Anthony Trollope's 'Kept in the Dark'
163 × 111 mm (6½ × 4¼ in)
Good Words, 1882, p.365
1978 P626 (3)

ETCHINGS

B223 Ruth, 1858
Etching printed in black, on India paper applied to white wove paper
Image: 127 × 88 mm (5 × 3½ in); plate: 177 × 127 mm (7 × 5 in); paper: 230 × 171 mm (9 × 6¾ in)
Insc bl: *1858 with monogram/ J E Millais,* bc: *London Published October 1st 1858 by E Gambart & Co 25 Berners Street Oxford Street*
1972 P69

Millais made *The Bridge of Sighs* and the above etching for the publication *Passages from the Poems of Thomas Hood, illustrated by the Junior Etching Club,* London, 1858.

B224 Happy Springtime, 1860
Etching on India paper, applied to white wove paper (proof before number)
Insc br: *1860 and monogram*
Image: 247 × 172 mm (9½ × 6¾ in); plate: 255 × 178 mm (10 × 7 in); paper: 495 × 327 mm (19¼ × 12¾ in)
A Selection of Etchings for the Etching Club, 1865 (1)
1972 P72

B225 Going to the Park, 1871–2
Etching, printed in black ink on India paper applied to cream wove paper
Insc bl: *J E Millais* and monogram, bc: *Going to the park,* br: *2*
Image: 179 × 128 mm (7 × 5 in); plate: 188 × 136 mm (7¼ × 5¼ in); paper: 369 × 265 mm (14½ × 10¼ in)
Etchings for the Art Union of London by the Etching Club, 1872 (2)
1972 P70

B226 The Baby-House, 1871–2
Etching, printed in black ink on India paper applied to cream wove paper
Insc bl: *J E Millais RA,* bc: *The baby-house,* br: monogram/ *9*
Image: 138 × 187 mm (5½ × 7¼ in); plate: 146 × 185 mm (5¾ × 7¼ in); paper: 264 × 370 mm (10¼ × 14½ in)
Etchings for the Art Union of London by the Etching Club, 1872 (9)
1972 P71

Select Bibliography

Artists of Victoria's England, Jacksonville, Florida, Cummer Gallery of Art, 1965.

Bennett, Mary: *P R B. Millais P.R.A.*, Liverpool, Walker Art Gallery and London, Royal Academy of Arts, 1967.

Engen, Rodney: *Pre-Raphaelite Prints*, London, Lund Humphries, 1995.

Gere, J. A.: *Pre-Raphaelite Drawings in the British Museum*, London, British Museum Press, 1994.

Goldman, Paul: 'A Consummate Illustrator – John Everett Millais', in Imaginative Book Illustration Society Journal No.2 *Singular Visions*, London, 2002, pp 37–51.

Hall, N. John: *Trollope and His Illustrators*, London, The Macmillan Press, 1980.

Hardie, Martin: *Catalogue of Prints – Wood Engravings after Sir John Everett Millais Bart., P.R.A. in the Victoria and Albert Museum*, London, Victoria and Albert Museum, 1908.

Holmes, C. J. (intro): *The Woodcut Illustrations of Millais*, London, Hacon and Ricketts, 1898.

John Everett Millais 1829–1896 – A Centenary Exhibition, Southampton, Southampton Institute, 1996.

Lockett, Richard: *Pre-Raphaelite Art from the Birmingham Museums and Art Gallery*, Hong Kong Museum of Art, 1984.

Lutyens, Mary (intro): *The Parables of Our Lord and Saviour Jesus Christ with Pictures by John Everett Millais*, New York, Dover Publications, 1975.

Millais, John Guille: *The Life and Letters of Sir John Everett Millais P.R.A.*, London, Methuen and Co, 1899 and 1900.

Pictures, Drawings and Studies for Pictures made by the late Sir J. E. Millais Bart., P.R.A., London, Fine Art Society, 1901.

Pre-Raphaelite Graphics, London, Hartnoll and Eyre Ltd, 1974.

The Pre-Raphaelites, London, Tate Gallery, 1984.

Sidey, Tessa: *Prints in Focus*, Birmingham, Birmingham Museums and Art Gallery, 1997.

Ullmann, Jennifer M.: '"The Perfect Delineation of Character." Process and Perfection in the Book Illustrations of John Everett Millais', in *Pocket Cathedrals – Pre-Raphaelite Book Illustration* (ed. Susan P. Casteras), New Haven, Yale Center for British Art, 1991, pp 55–65.

Warner, Malcolm: *The Drawings of John Everett Millais*, London, Arts Council of Great Britain, 1979.

Whitley, A. E.: *Catalogue of the Permanent Collection of Drawings*, Birmingham, Birmingham Museum and Art Gallery, 1939.

Wildman, Stephen: *British Watercolours from Birmingham*, Birmingham, Birmingham Museums and Art Gallery, 1991.

Wildman, Stephen: *Visions of Love and Life: Pre-Raphaelite Art from the Birmingham Collection, England*, Alexandria, Virginia, Art Services International, 1995.

Woof, Robert: *Tennyson (1809–1892): A Centenary Celebration*, Grasmere, The Wordsworth Trust, 1992.

Index